Remembering
Minnesota

Susan Marks

TURNER
PUBLISHING COMPANY

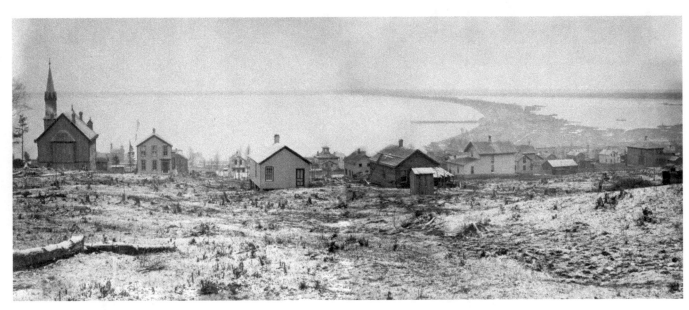

A panoramic view of the 1870 pioneer town of Duluth, facing Lake Superior. Duluth first gained nationwide attention in the 1850s when rumors of copper-rich land began to circulate. Many sought their fortune in Duluth, sparking a land rush in the area. There was little actual copper, however, and pioneer interest soon turned toward iron ore mining, railroads, and shipping.

Remembering
Minnesota

Turner Publishing Company

4507 Charlotte Avenue • Suite 100
Nashville, Tennessee 37209
(615) 255-2665

Remembering Minnesota

www.turnerpublishing.com

Library of Congress Control Number: 2010932643

ISBN: 978-1-59652-717-1

Printed in the United States of America

ISBN: 978-1-68336-854-0 (pbk)

10 11 12 13 14 15 16—0 9 8 7 6 5 4 3 2 1

CONTENTS

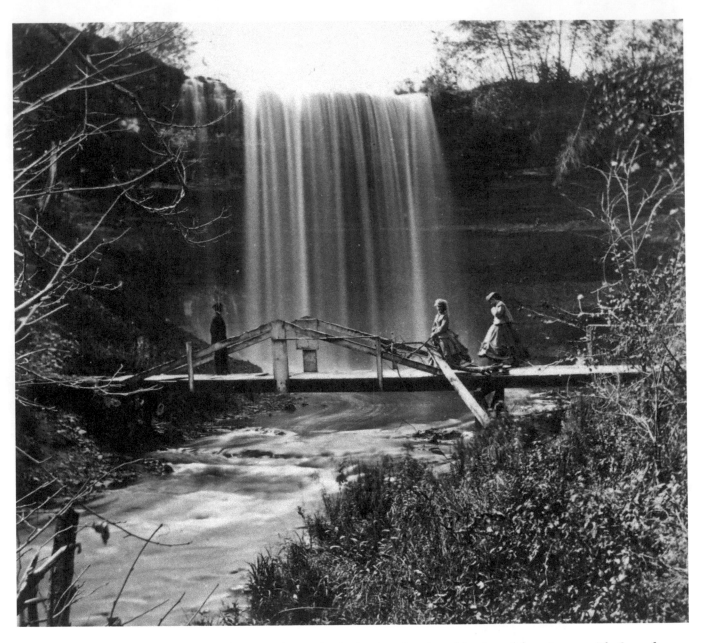

Visitors to Minnehaha Falls in Minneapolis, a popular tourist destination after the publication of the epic poem *The Song of Hiawatha* by Henry Wadsworth Longfellow in 1855. Longfellow never visited the falls, but he was inspired by the stories of Mary Eastman and Henry Rowe Schoolcraft about American Indian culture and the imagery of the falls.

Acknowledgments

This volume, *Remembering Minnesota,* is the result of the cooperation and efforts of many individuals, organizations, and corporations. It is with great thanks that we acknowledge the valuable contribution of the following for their generous support:

Library of Congress
Minnesota Historical Society

We would also like to thank the following individuals for valuable contributions and assistance in making this work possible:

Doug Bekke, Minnesota Military Museum
Jeff Forester
Carolyn Kneisl, Kandiyohi County Historical Society
Sarah LaVine, Stearns History Museum
Patricia Maus, Northeast Minnesota Historical Center
Bob Sandeen, Nicollet County Historical Society
David Stevens, the Mill City Museum, Minnesota Historical Society
Minnesota Historical Society's Library Staff

PREFACE

Minnesota has thousands of historic photographs that reside in archives, both locally and nationally. This book began with the observation that, while those photographs are of great interest to many, they are not easily accessible. During a time when Minnesota is looking ahead and evaluating its future course, many people are asking, How do we treat the past? These decisions affect every aspect of the state—architecture, public spaces, commerce, infrastructure—and these, in turn, affect the way that people live their lives. This book seeks to provide easy access to a valuable, objective look into the history of Minnesota.

Although the photographer can make decisions regarding subject matter and how to capture and present it, photographs, unlike words, are less prone to interpret history subjectively. This lends them an authority that textual histories sometimes fail to achieve, and offers the viewer an original, untainted perspective from which to draw his own conclusions, interpretations, and insights.

This project represents countless hours of review and research. The researchers and writer have reviewed thousands of photographs in numerous archives. We greatly appreciate the generous assistance of the individuals and organizations listed in the acknowledgments of this work, without whom this project could not have been completed.

The goal in publishing this work is to provide broader access to this set of extraordinary photographs that seek to inspire, provide perspective, and evoke insight that might assist people who are responsible for determining Minnesota's future. In addition, the book seeks to preserve the past with adequate respect and reverence.

With the exception of touching up imperfections that have accrued with the passage of time and cropping where necessary, no changes have been made. The focus and clarity of many images is limited by the technology and the ability of the photographer at the time they were taken.

The work is divided into eras. Beginning with some of the earliest known photographs of Minnesota, the first section records photographs through the end of the nineteenth century. The second section spans

the first decade of the twentieth century. Section Three moves from 1910 through the 1920s. Section Four covers the Great Depression and World War II years, and the last section proceeds from the end of the war to the 1950s.

In each of these sections we have made an effort to capture various aspects of life through our selection of photographs. People, commerce, transportation, infrastructure, religious institutions, and educational institutions have been included to provide a broad perspective.

We encourage readers to reflect as they go traveling in Minnesota, strolling through its parks and the neighborhoods of its cities, and visiting its countryside and many lakes. It is the publisher's hope that in utilizing this work, longtime residents will learn something new and that new residents will gain a perspective on where Minnesota has been, so that each can contribute to its future.

—Todd Bottorff, Publisher

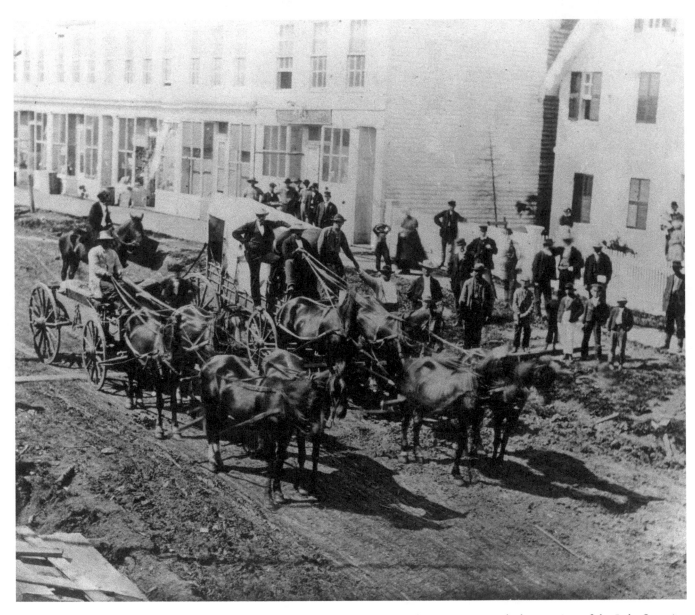

On August 1, 1870, the St. Paul and Lake Superior Stagecoaches ceremoniously quit service with the opening of the Lake Superior and Mississippi Railroad. On this day, the first train arrived in Duluth from St. Paul, a roughly 150-mile trip that took 16 hours.

Minnesota on the Map

(1860s–1899)

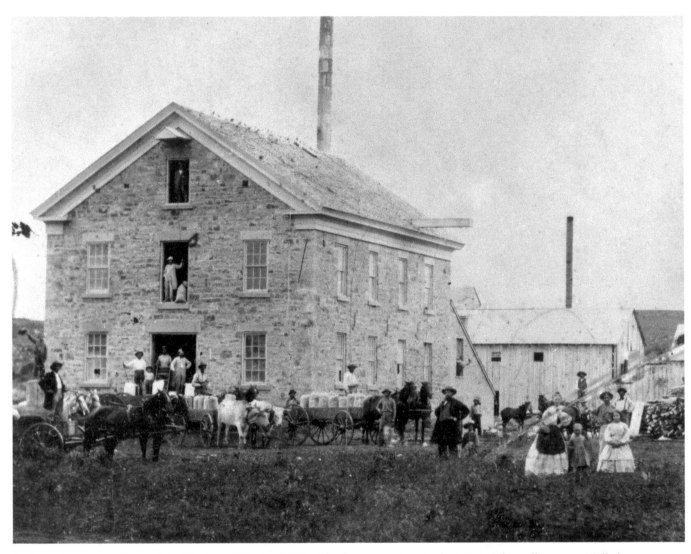

Early settlers pose in front of the Bierbauer Woolen Mill in Mankato sometime in the 1860s. The mill's owner, Wilhelm Bierbauer, fought in a battle against the Dakota Indians in nearby New Ulm during the U.S.-Dakota War of 1862. After the war, more than 300 Dakota men were tried for various offenses and sentenced to die. Upon review of the convictions, President Lincoln commuted the sentences of all but 38. Those 38 Dakotas were executed in a mass hanging in Mankato—the largest mass execution in U.S. history.

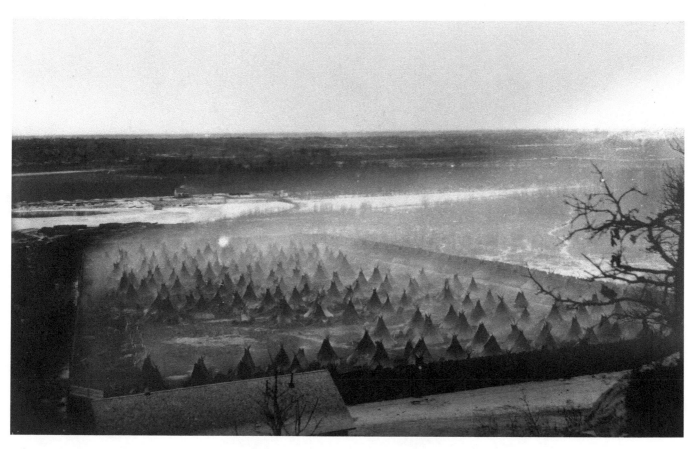

The camp where captured Dakotas were incarcerated on the Minnesota River flats below Fort Snelling, following the U.S.-Dakota War. About 1,600 other Dakotas—mostly nonparticipants in the war—were forced into this camp.

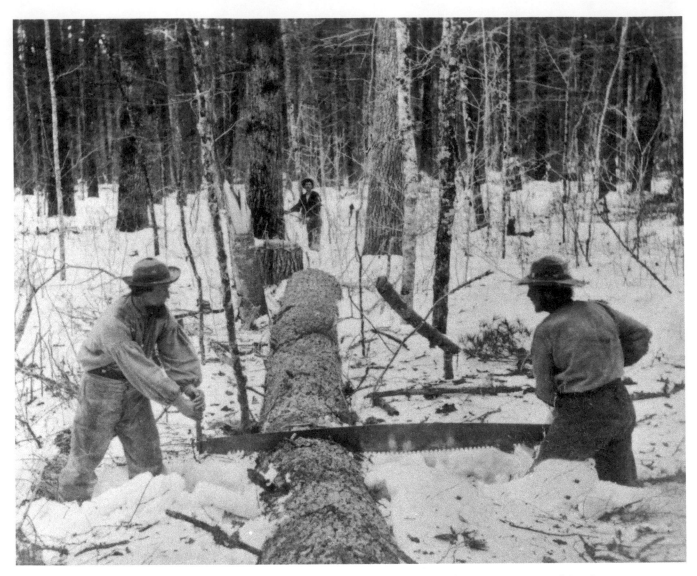

Lumberjacks sawing a white pine in one of Minnesota's many thriving pineries around 1865. Minnesota white pine was a lumberman's dream, because it was light, buoyant for the springtime river log drives, and easy to cut in the sawmills. At the same time, the pine was strong and durable.

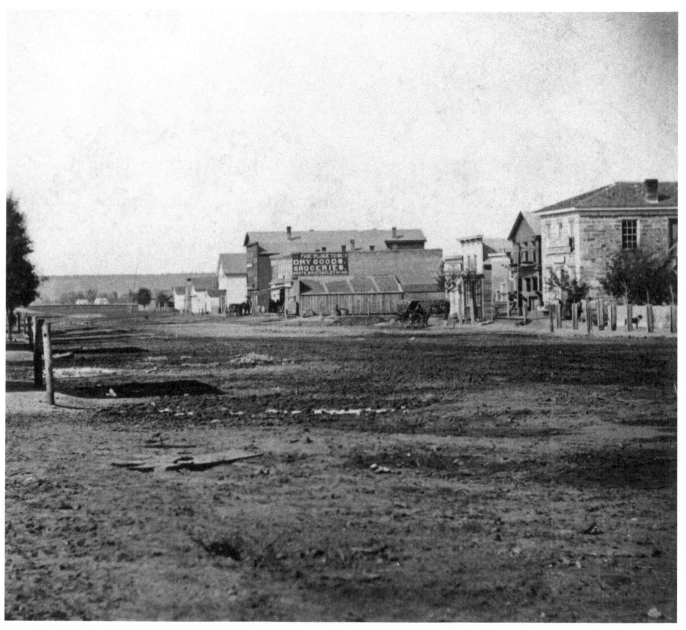

Minnesota Avenue in St. Peter as it looked in 1867. An attempt was made to move the territorial capital from St. Paul to St. Peter in 1857, but territorial council member Joseph J. Rolette famously took the legislative bill and hid with it in the St. Paul Hotel until the end of the legislative session, when it was too late for the bill to be signed.

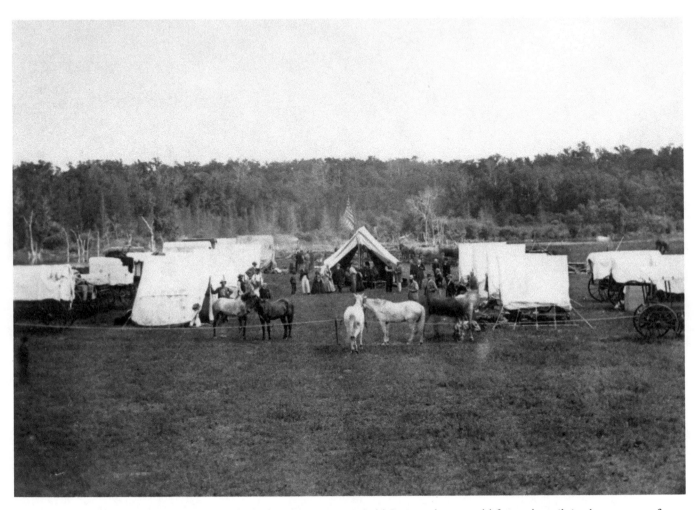

The expedition party for the Northern Pacific Railroad camping at Cold Spring, along an old fur trade trail, in the summer of 1869. Congress gave the Northern Pacific a colossal land grant to construct a railway from Lake Superior to Puget Sound.

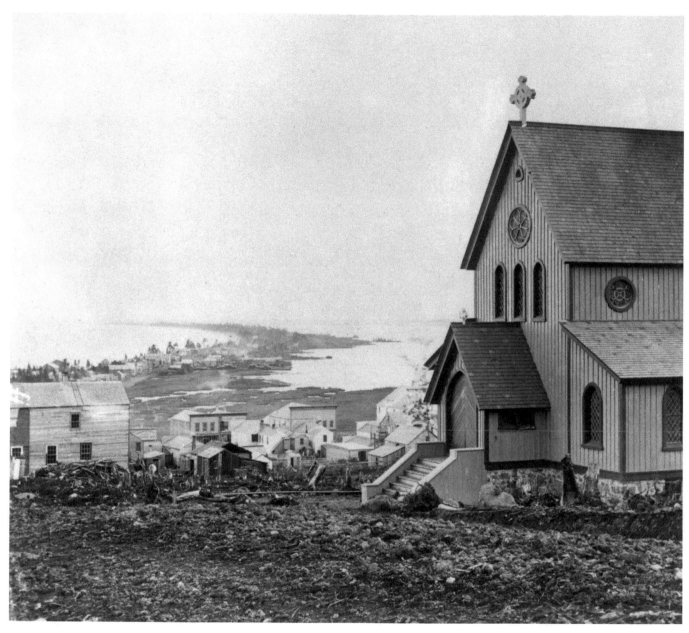

A view of St. Paul's Episcopal Church, Duluth's oldest church, as it looked in 1870. During its construction, the church was often referred to as "Jay Cooke's church," in honor of the town's Episcopalian financier. In October of 1870, Bishop Henry B. Whipple came to Duluth for a formal dedication, announcing the church's official name of St. Paul.

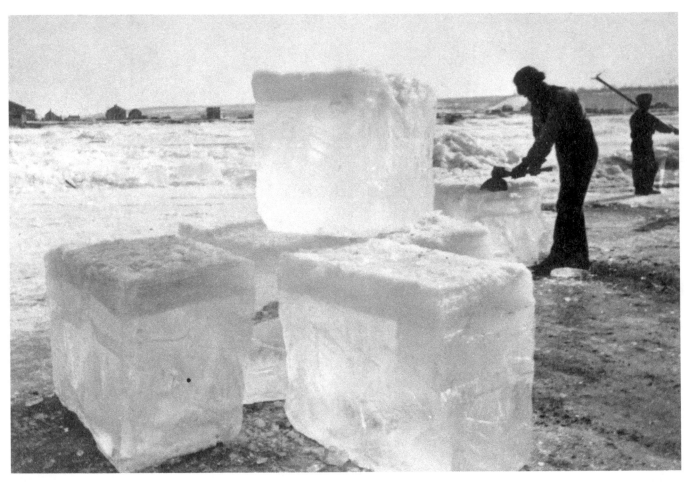

Across Minnesota, ice harvesting usually took place in January, when lakes and rivers were frozen at least 18 to 20 inches thick. Horse-drawn wagons or sleds hauled the ice to icehouses for storage. During the summer, ice was delivered, block by block, to homes and businesses for their iceboxes. Railroads, also a large ice clientele, used it to cool the boxcars when shipping produce, dairy, and meat.

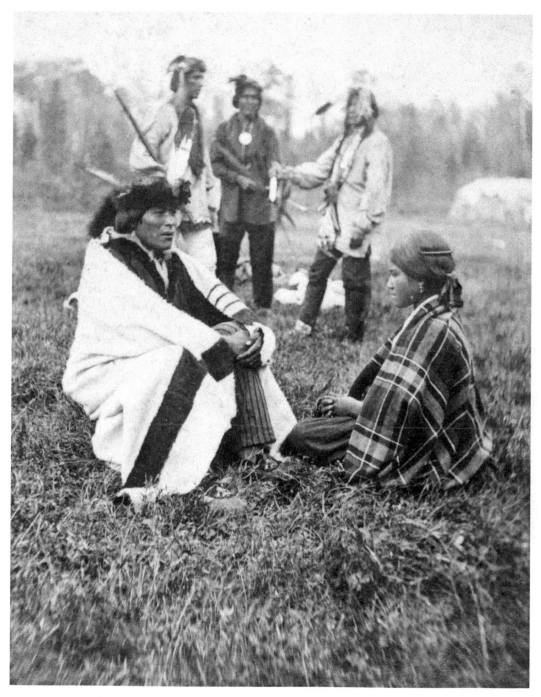

This image was recorded around 1870 and was originally titled "Chippewa Wedding," although it is likely that it was not a wedding at all, but a staged photograph of Ojibwe Indians that was sold as a stereoscopic image and postcard.

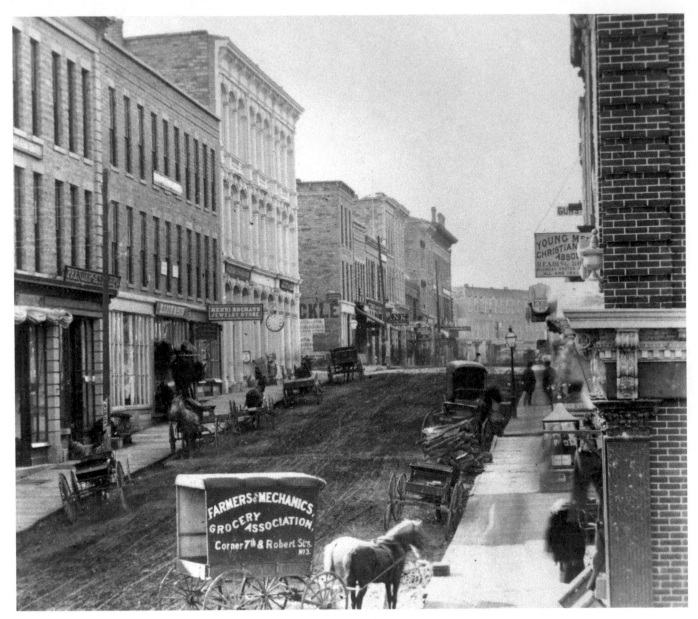

A view of Third Street in downtown St. Paul in 1873 with a horse-drawn wagon advertising the Farmers and Mechanics Grocery Association. The city evolved from a pioneer village in the late 1830s to a metropolitan area with strong agricultural roots. This thriving warehouse district connected nearby farms with the wide distribution network provided by railways and the Mississippi River.

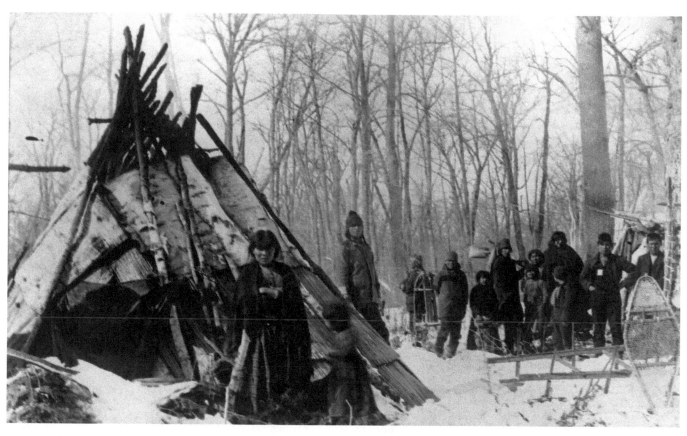

An Ojibwe winter camp in South Harbor Township around 1875. The township is located in the Mille Lacs Indian Reservation region, believed to have been one of the first areas in Minnesota settled by humans.

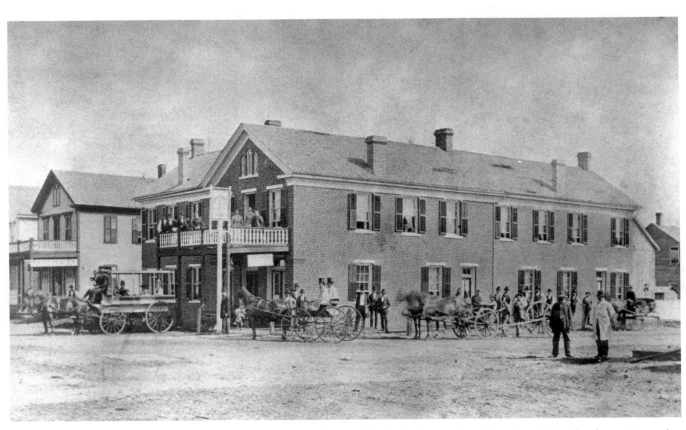

The Minnesota House hotel, shown here in 1876, was one of several hotels that catered to visitors in the St. Cloud area. Located in the center of the state, on the Red River Trail, the city was perfectly situated to accommodate the needs of travelers on their way from St. Paul back to North Dakota or Canada.

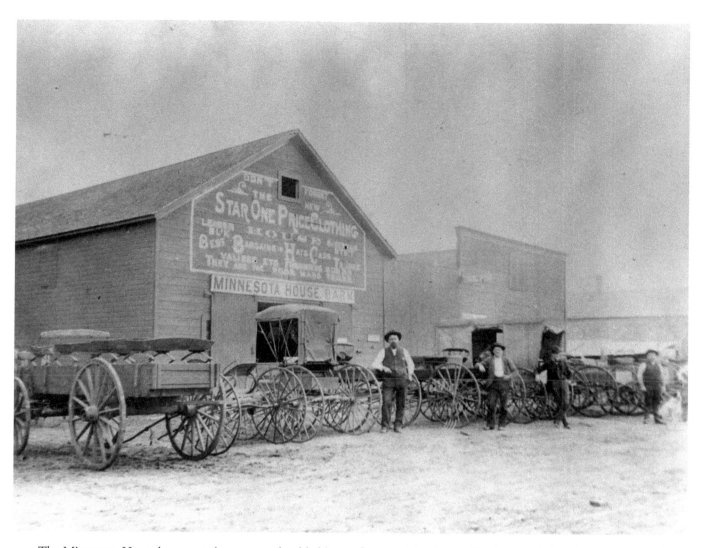

The Minnesota House barn rented wagons and stabled horses for overnight visitors. The barn and the Minnesota House hotel were located in the commercial hub of St. Cloud in 1876.

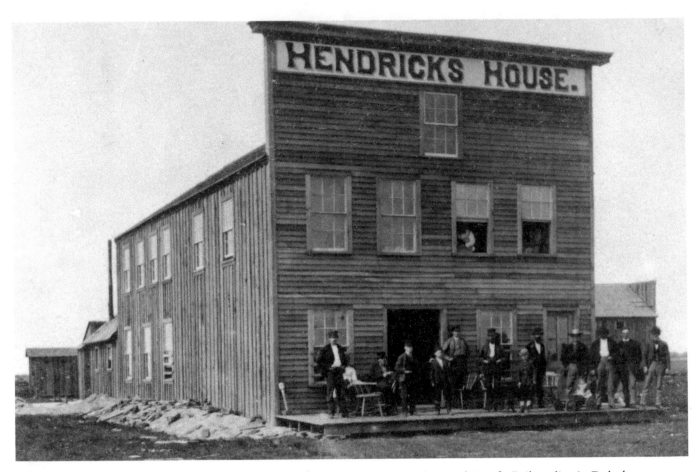

The Hendricks House hotel was located not in Hendricks, Minnesota, but on the North Pacific Railway line in Duluth, near Lake Street. Shown around 1876, the hotel is a perfect example of those that sprang up all over Minnesota to accommodate railroad passengers.

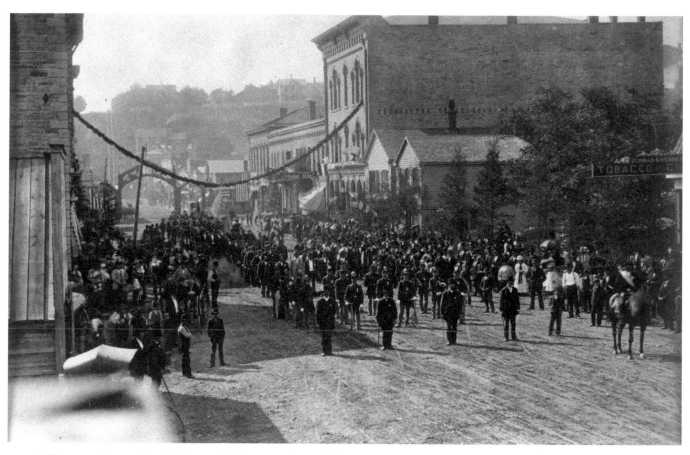

Stillwater celebrates the ninth annual Minnesota Saengerfest—a German music festival—in 1877. This event brought various German singing societies together for socializing, competition, and celebration of German culture.

In late March of 1881, a blizzard hit southern Minnesota, creating snowdrifts so high that trains could not pass. This image of a man standing on top of a snowbound train was massively reproduced for postcards and stereoscopes.

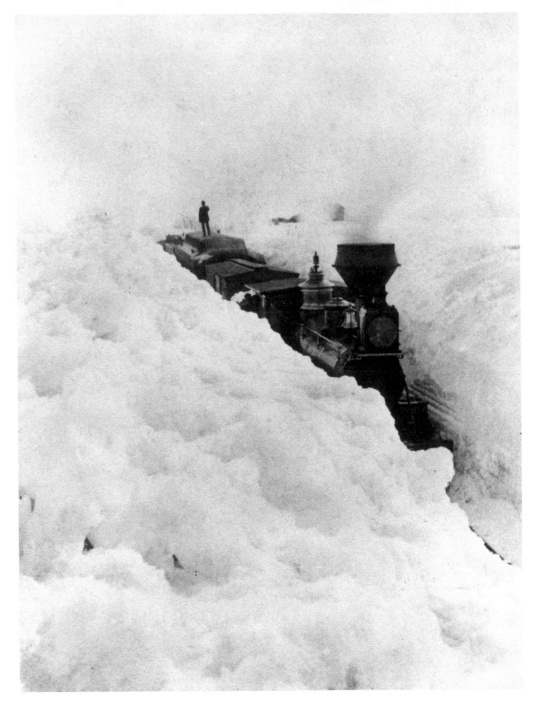

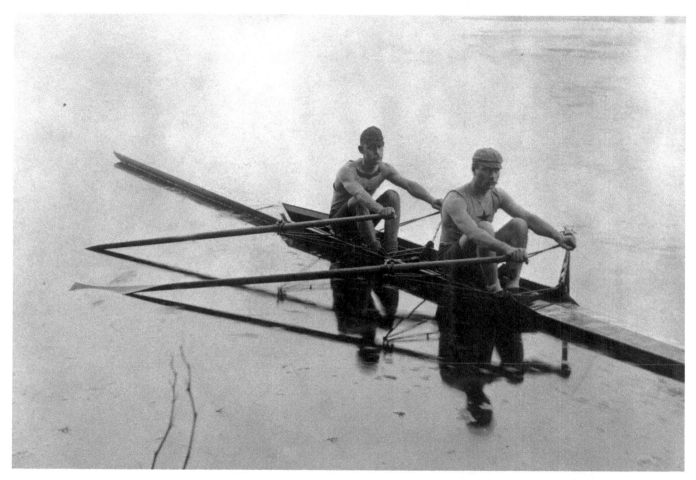

Two rowers from the Minnesota Boat Club in the 1880s. The club was established on Raspberry Island in St. Paul in the 1870s and is said to be the oldest athletic organization in the state. Members like these two had to adhere to strict rules, with punitive repercussions for breaking them. For example, refusing to obey captain's orders meant a fine of $2. Smoking in the dressing room brought a $1 fine.

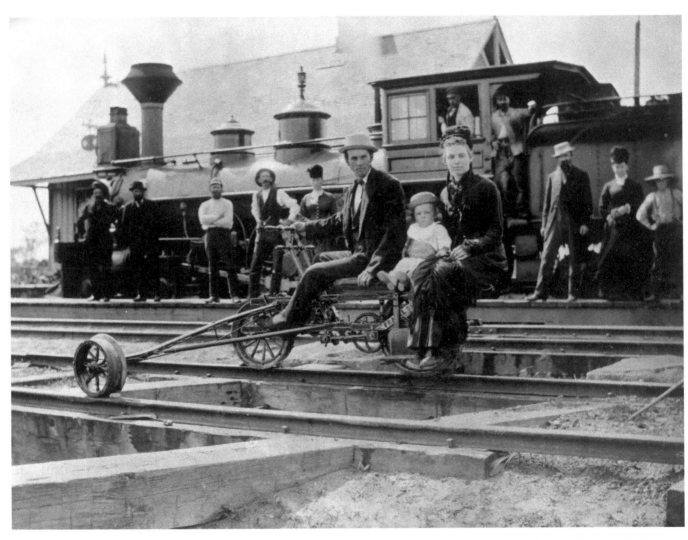

On July 13, 1881, a man, woman, and child pose on a velocipede handcar in a Minnesota rail yard. This novel, three-wheel railroad handcar was propelled by a combination of hand and foot power. The velocipede was likely used for track inspection, rather than the leisure riding this photo might suggest.

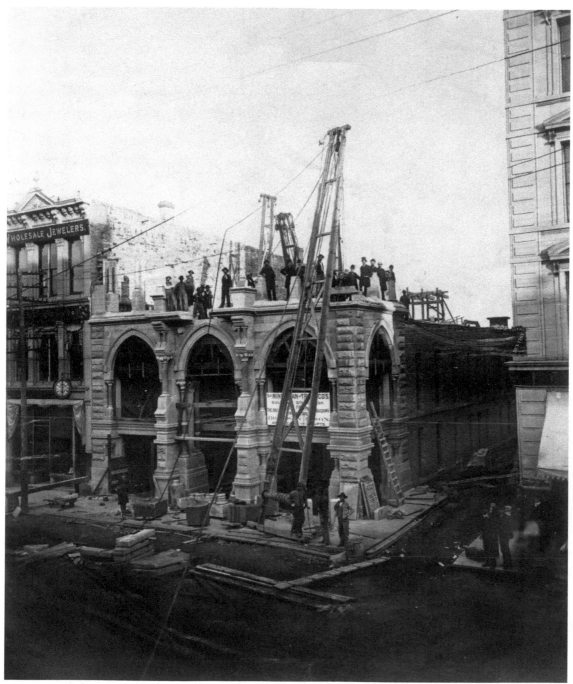

Construction pauses for a moment on the Minnesota Loan and Trust building, located at 313 Nicollet Avenue in downtown Minneapolis, in 1884. At the time, Minneapolis was flourishing financially, due to the seismic boom in flour and lumber milling and the growth of the railroads.

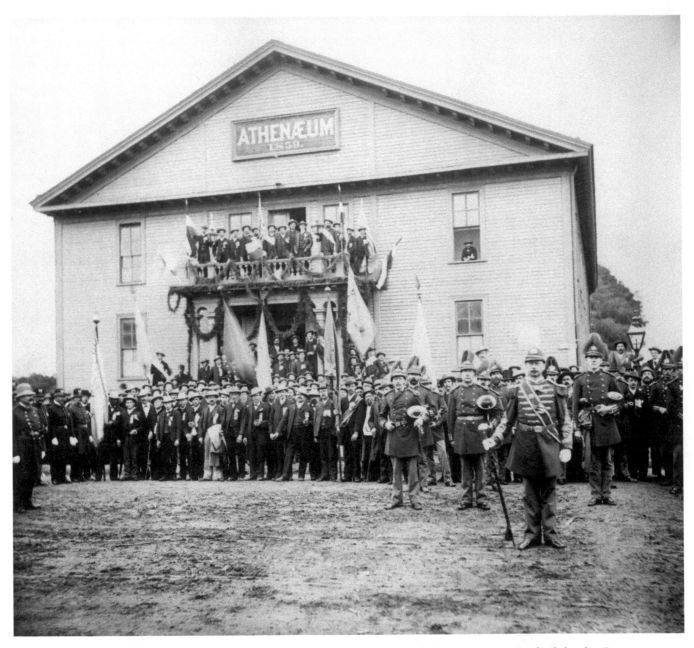

Pictured here around 1885, the Athenaeum in St. Paul, located at Exchange and Sherman streets, was built by the German Reading Society to serve as a meeting place for the German community in the St. Paul area.

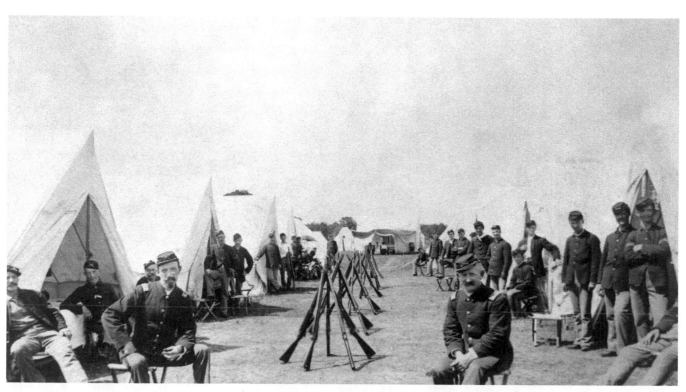

Members of the Minnesota National Guard's Company D pose outside their tents around 1885 at an encampment in either White Bear Lake or Fort Snelling. The tradition-rich military command of "stack arms" allowed weapons to be grounded in a uniform manner while keeping them clean and easily accessible.

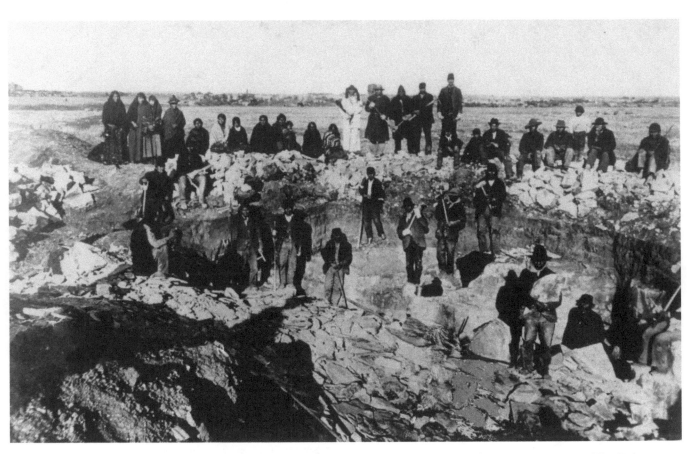

Dakota Indians pose for a postcard in Pipestone, located in the extreme southwest corner of Minnesota, in 1893. The Dakotas have a deep connection to the area, and a long history of mining the red quartzite used for making pipes. Pipestone National Monument, designated by the United States in 1937, is not a traditional monument but the quarry itself.

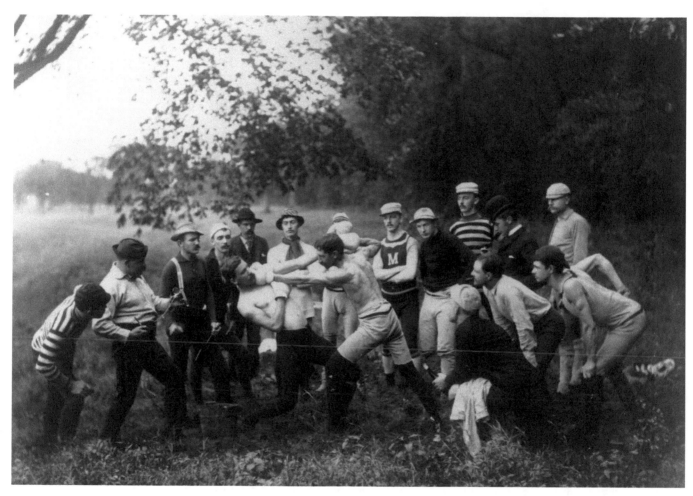

Members of the Minnesota Boat Club observe a boxing match, probably between two of their own, during an 1890s picnic excursion. The club's stated purpose was for the "mutual improvement of the physical bodily condition of its members."

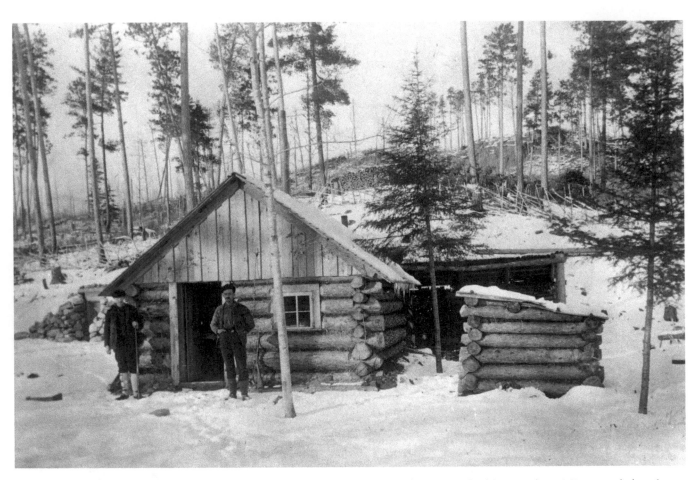

A claim shanty during Minnesota's second gold rush, in the mid-1890s. The discovery of gold in northern Minnesota led to the Vermilion Lake gold rush of 1865-66. Very little gold was found, and prospectors abandoned the area by 1867. But gold was struck again in 1893, on Little American Island in Rainy Lake (along the United States–Canada border). The Little American Mine is the only productive gold mine ever to operate in Minnesota.

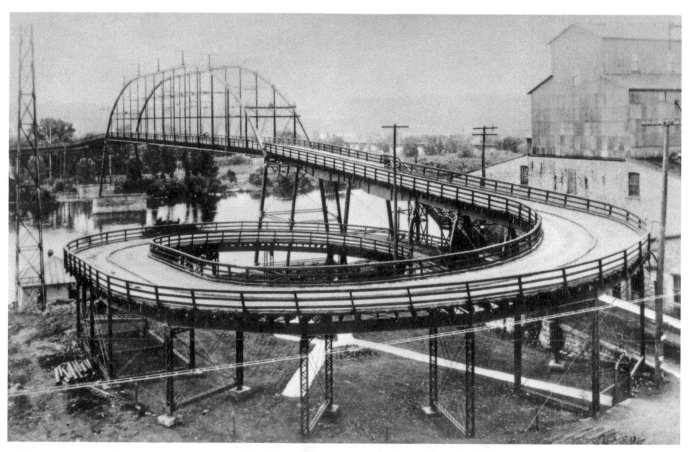

This wooden spiral bridge spanning the Mississippi River at Hastings opened in 1895 to great fanfare as reportedly the first of its kind. The spiral design, by Benjamin D. Cadwell of Hastings, was intended to minimize the impact of the bridge approach on the riverfront business district.

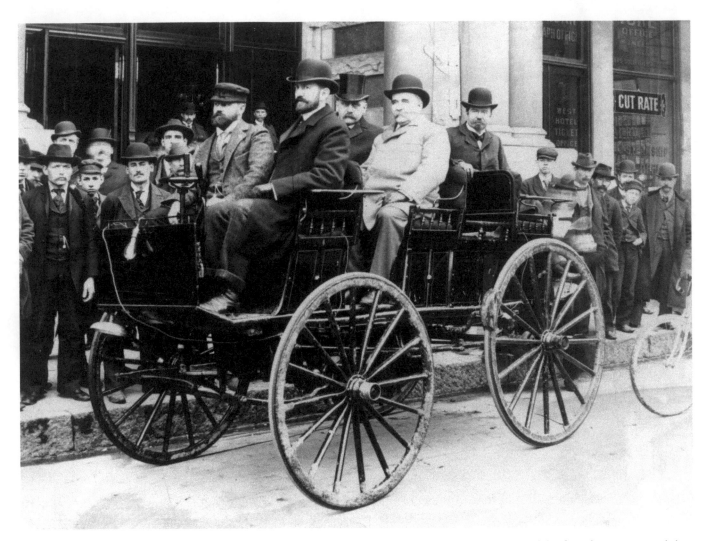

On April 14, 1896, a crowd gathers in front of the West Hotel in Minneapolis to get a look at one of the first electric automobiles in the city. This car was exhibited at the 1896 Bicycle Show held in the Exposition Building.

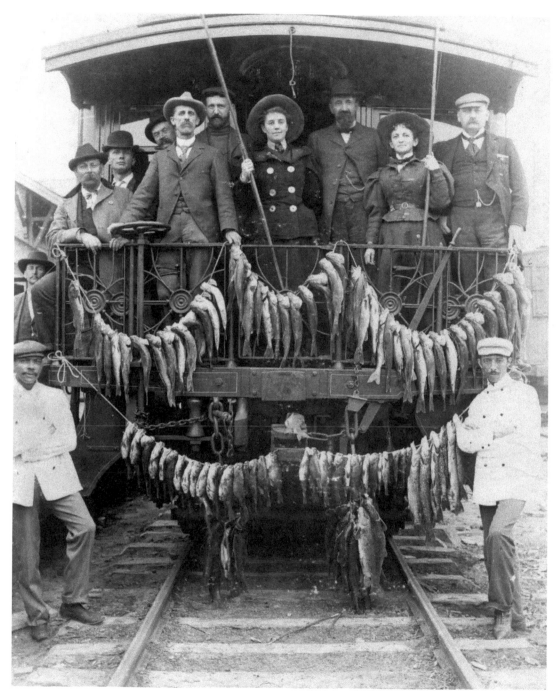

Men and women traveling back from an 1896 fishing expedition on Leech Lake display their catches after just one and a half hours of fishing. Leech Lake is located in northern Minnesota and is renowned for its muskie, walleye, and northern pike.

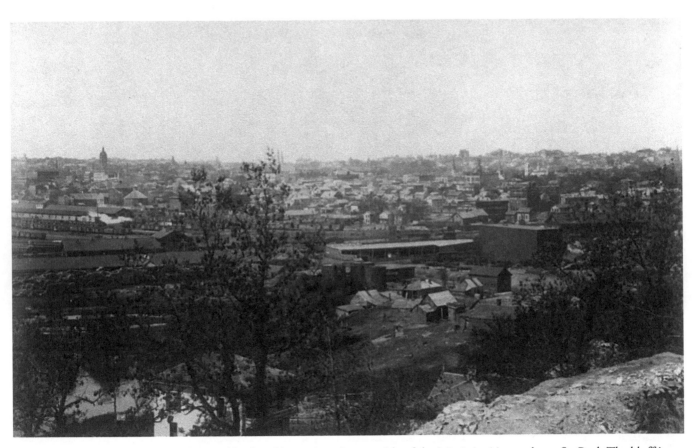

An 1896 view from Dayton's Bluff, a neighborhood located on the east side of the Mississippi in southeast St. Paul. The bluff is named for Lyman Dayton, a real estate investor and president of the Lake Superior and Mississippi Railroad. Dayton's Bluff was called "the most picturesque and beautiful district of the city" by the *St. Paul Pioneer Press* on January 1, 1887.

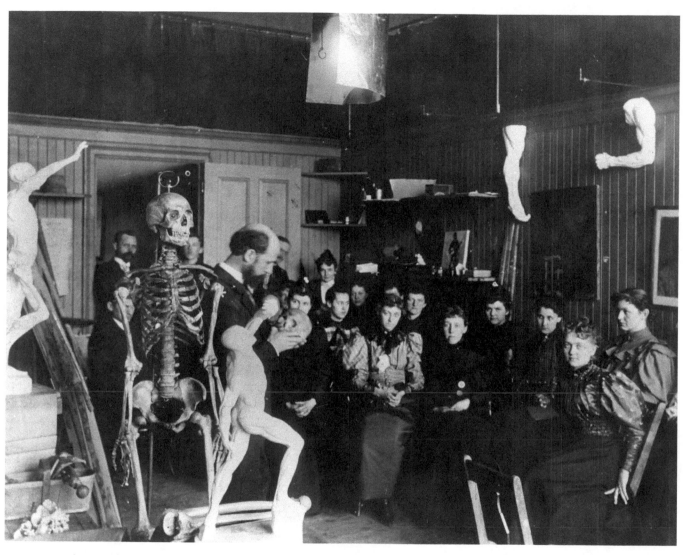

Art students at the University of Minnesota in the 1890s attend a lecture on the human body given by Dr. Richard Olding, a professor of physiology. When the university was founded, on February 25, 1851, women weren't allowed to enroll. Seven years later, enrollment was opened to women, but during the Civil War the university shut down. It reopened in 1869, with a class of 15 students.

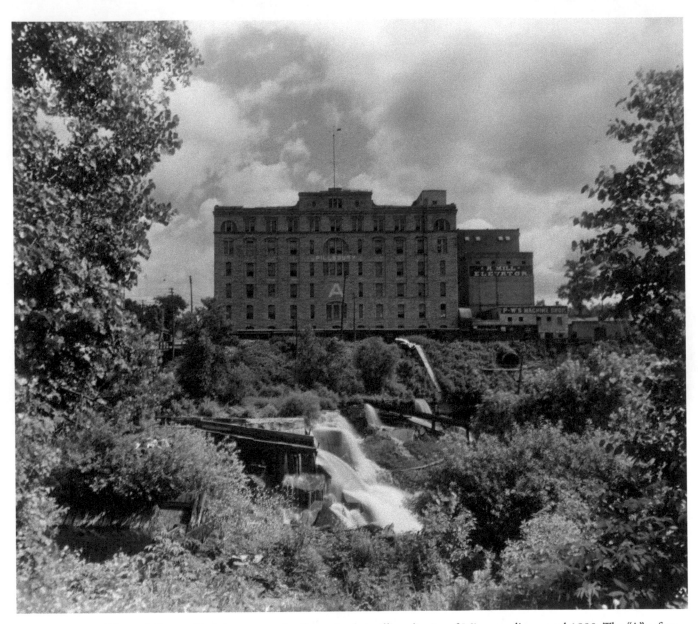

The limestone Pillsbury A flour mill, sluiceways, and tailraces in the milling district of Minneapolis around 1890. The "A" refers to the largest of several Pillsbury mills at the Falls of St. Anthony. This mill was the first in the area to use electrical lighting and had the capacity to produce 5,107 barrels of flour per day. On this exact location 33 years earlier, the Pillsbury family ran a hardware store.

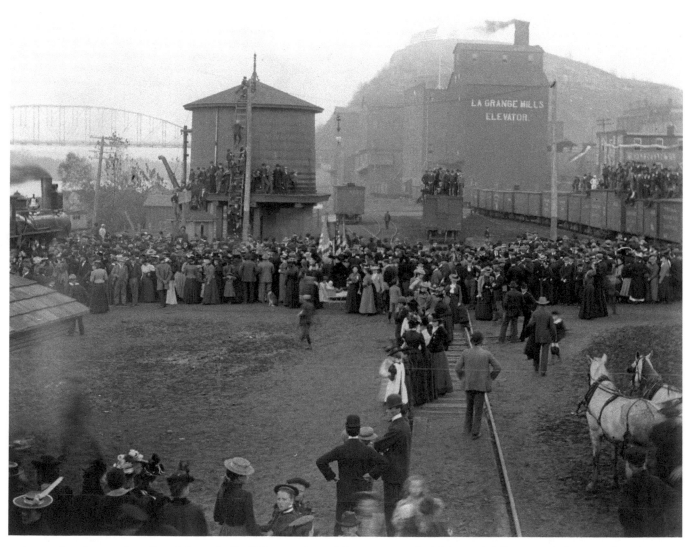

A crowd gathers at the railroad depot in Red Wing to show their support to the Thirteenth Minnesota Infantry as they depart in 1898 to serve in the Spanish-American War. The unit lost more than 40 men during the war, mostly due to disease.

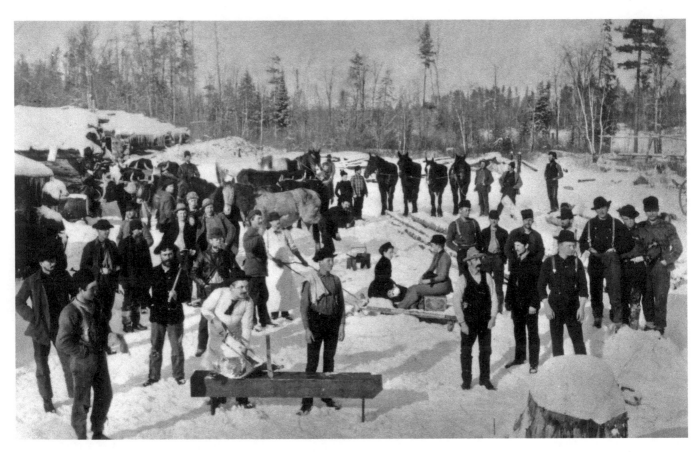

An uncommon staged scene in a northern Minnesota lumber camp around 1898. During the golden era of lumber in the state, lumberjacks were constantly on the move. More than 20,000 jacks and 10,000 draft horses worked in the pineries of Minnesota. Another rarity in this photo is the presence of women—who were not permitted in lumber camps.

THE THREE FRONTIERS

(1900–1909)

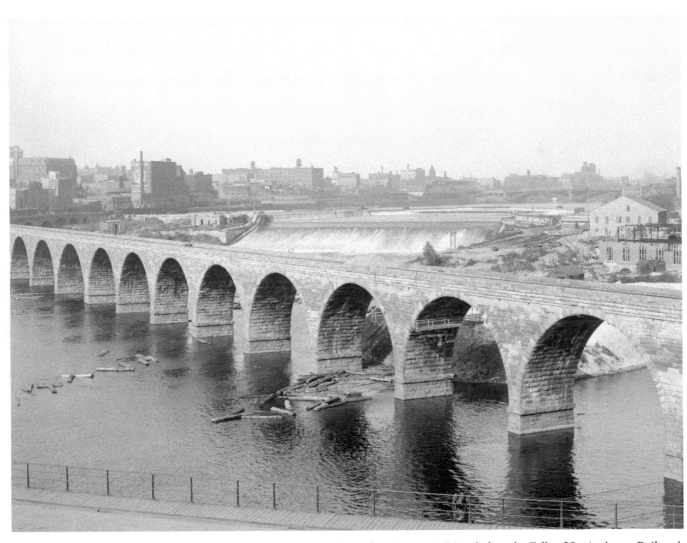

The Stone Arch Bridge, shown here at the turn of the century, spans the Mississippi River below the Falls of St. Anthony. Railroad tycoon James J. Hill built the bridge in 1883 to better connect his Great Northern Railway to the milling district of Minneapolis. The bridge eventually fell into long-term disuse but made a comeback in the 1990s as a newly refurbished bridge for pedestrians.

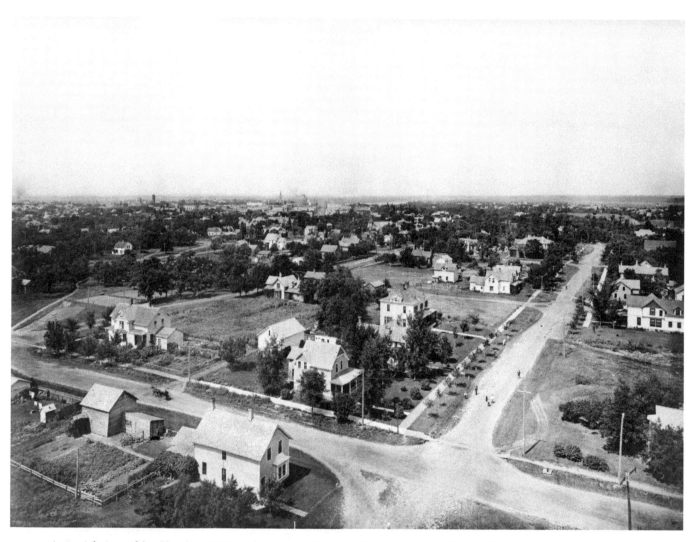

An aerial view of St. Cloud in 1902 at the corner of Second Avenue South and Seventh Avenue South. *Minneapolis Tribune* photographer George R. Lawrence scaled a newly erected, 100-foot "trestle-work tower" to get this shot of the city for the newspaper.

Three elegantly dressed visitors at the Minnesota State Fair in 1903. Women fairgoers in full-length dresses, hats, and parasols, and men in suits, were a familiar sight around the turn of the century.

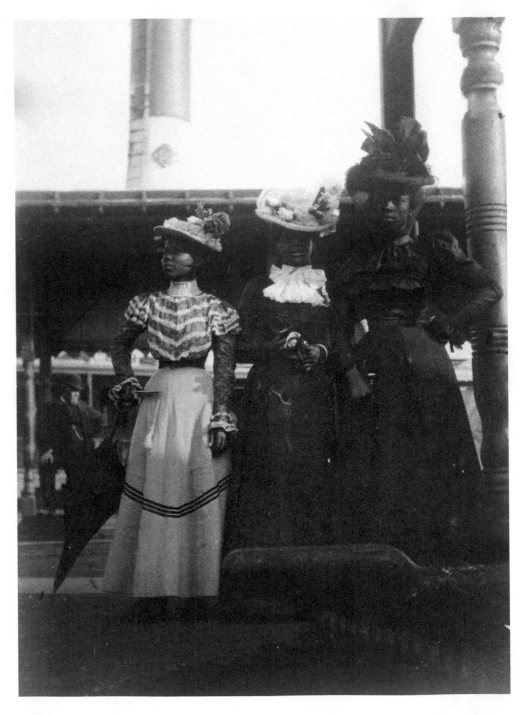

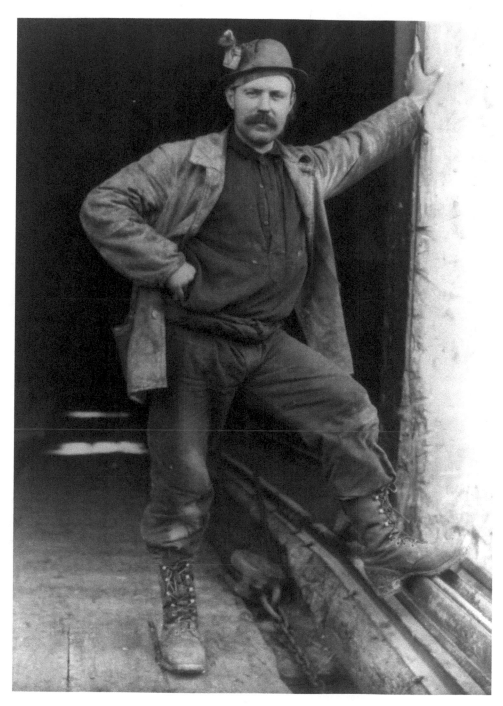

A miner on the Mesabi Range in 1903. The demand for men to work on the range coincided with massive emigration from Europe. Because mining required few English language skills and little in the way of prior experience, new immigrants easily found work on the range. By 1900, 70 percent of immigrants on the iron ranges came from Slovenia, Sweden, Croatia, and Finland.

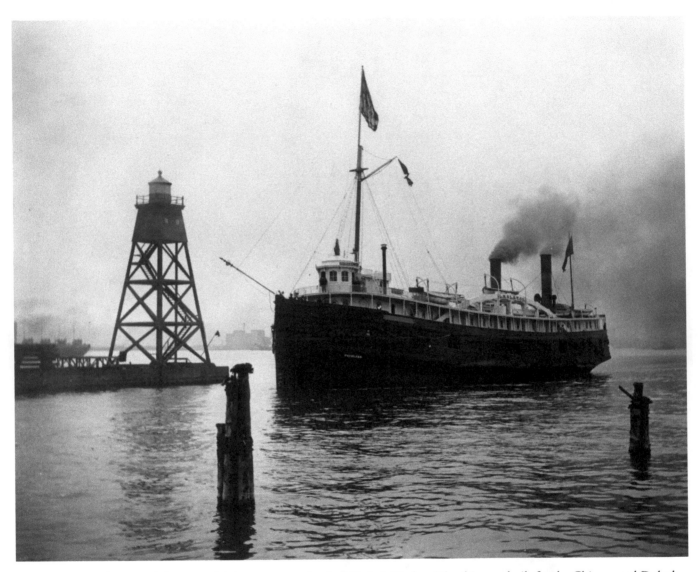

The steamer *Peerless* around the turn of the century, coming into Duluth Harbor. The ship was built for the Chicago and Duluth route in 1872 as an answer to the increasing traffic of passenger and package freight. On September 7, 1899, *Peerless* hit the barge *Stewart* in Duluth harbor. It took $8,000 to refurbish the 27-year-old *Peerless*.

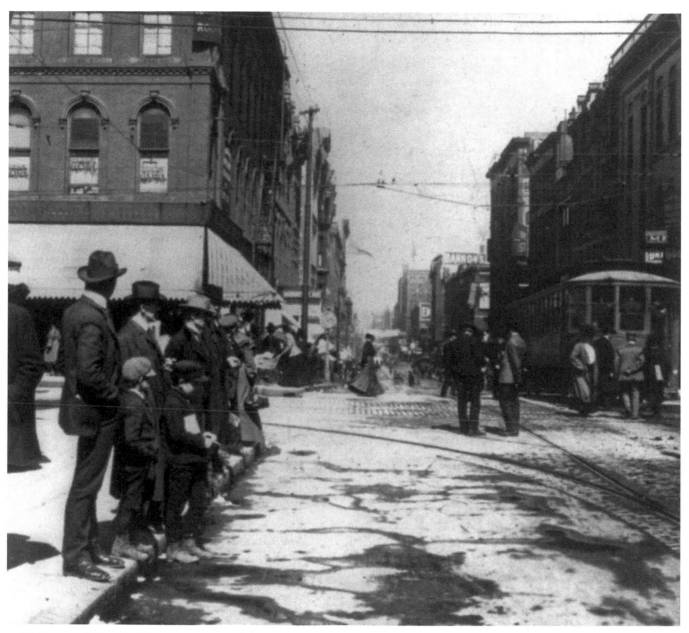

This view of Seventh Street shows a typical downtown St. Paul scene in 1905. The city's elaborate streetcar system connected St. Paul with Minneapolis and beyond. Increasingly, St. Paulites moved to "streetcar suburbs" on the outskirts of town, commuting to work each day.

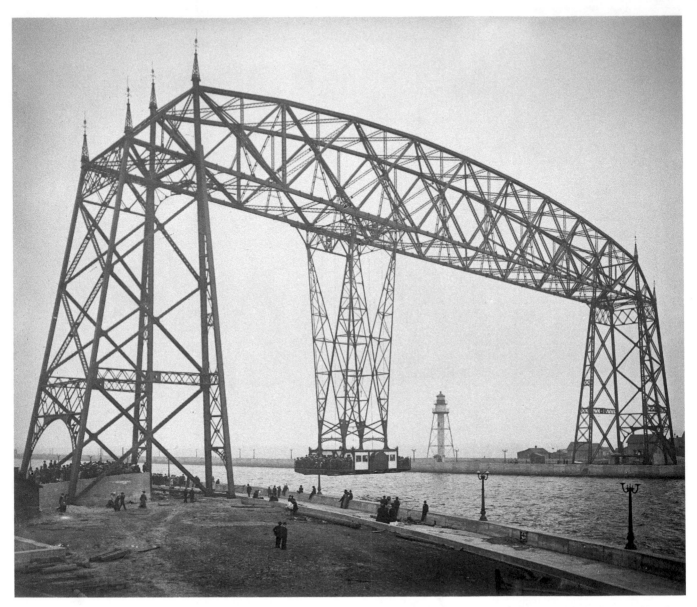

Originally built in 1905, the Aerial Bridge in Duluth was a popular tourist attraction. To accommodate both tall ships and land traffic, the bridge had a gondola that could carry 350 people, plus wagons, streetcars, or automobiles across the canal. The gondola was suspended below the main span and traveled on rails from one side of the bridge to the other. The trip across the canal took about a minute.

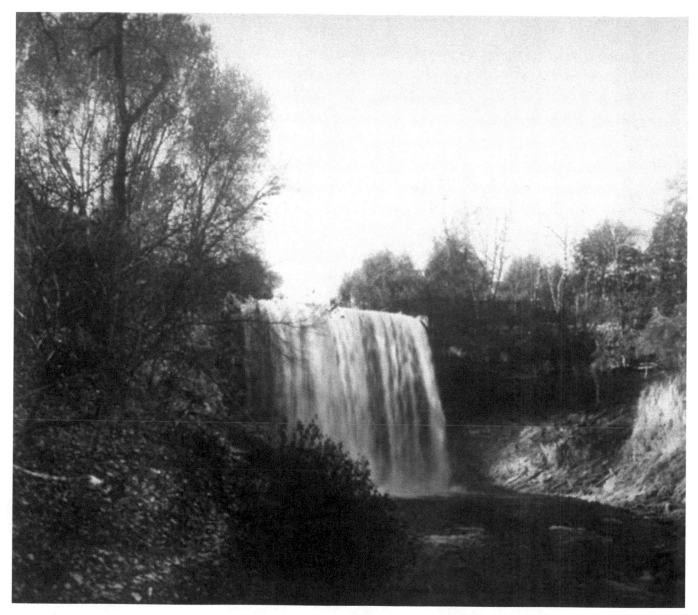

Minnehaha Falls in Minneapolis, pictured around 1906. The falls have long been an important spiritual site to the Dakota people. Minnehaha means "falling water" in Dakota—not "laughing water," as it is often translated. The "laughing water" translation comes from Mary Eastman's book *Dacotah,* published in 1849. The Dakota called Minnehaha Creek "Wakpa Cistinna," meaning "Little River."

A bird's-eye view of downtown St. Paul on Cedar Street in 1908. While the city was outpaced by its rival Minneapolis in population and commerce, St. Paul was growing and expanding, especially its meatpacking industry and the production of beer, steel, leather goods, and butter.

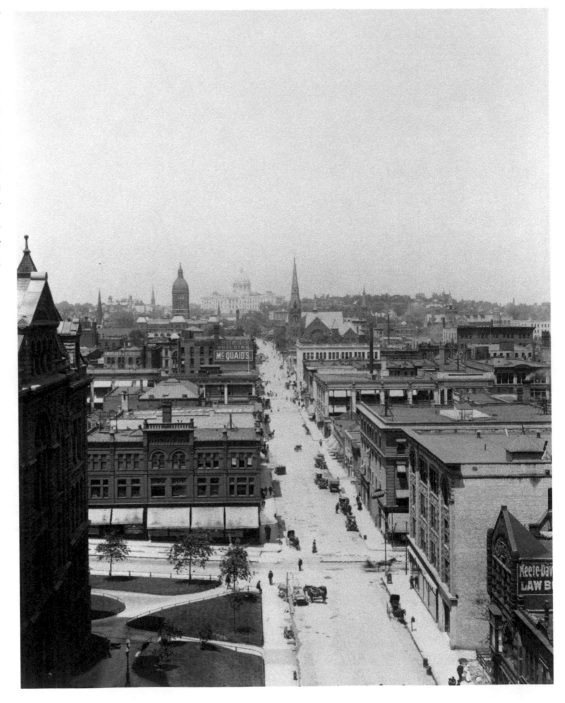

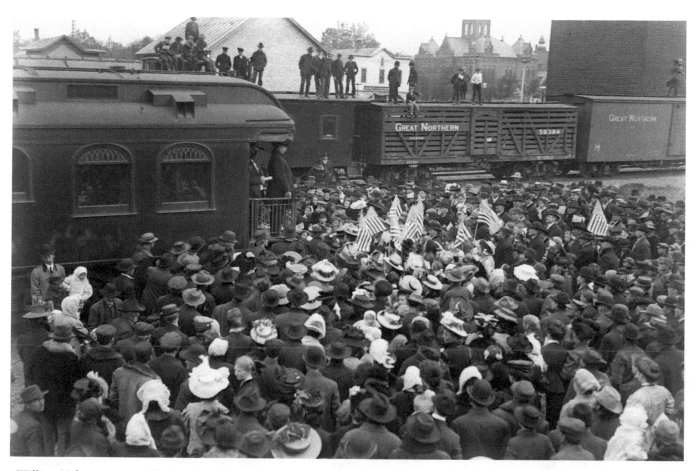

William Taft campaigned for president by train in 1908, stopping in Ada, shown here, after speaking in the Twin Cities, southern Minnesota, and Iowa. During his campaign, Taft projected his voice to the crowds so often that he suffered from laryngitis. Members of his campaign team were quick to step in and do the talking for Taft.

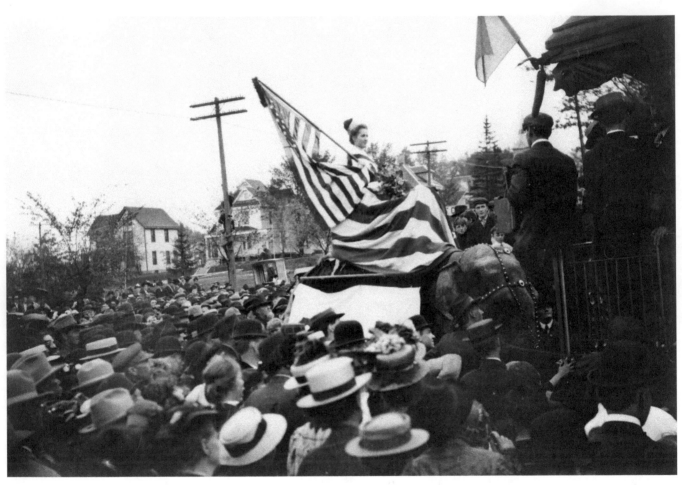

Eight thousand people showed up to hear William Taft's presidential campaign speech in Northfield in 1908. The Taft Club in Northfield borrowed an elephant from a street carnival to greet the train. Taft told the crowd that he was pleased to see such a great symbol of the Republican Party, and then he joked that he was too heavy to ride it himself (Taft weighed over 300 pounds).

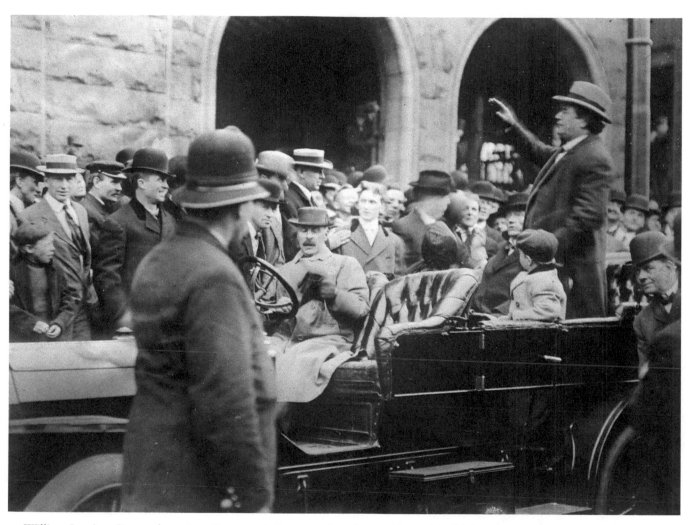

William Jennings Bryan, three-time Democratic Party nominee for president, visited Minnesota in 1908. Bryan was known as a great orator, but is pictured here, on a Sunday, refusing to speak. Bryan lost his presidential bid that year to William Taft.

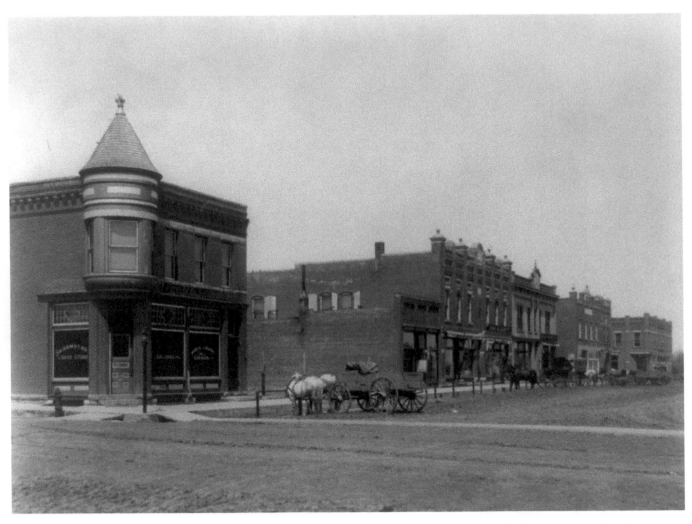

A view of downtown Goodhue, facing north, around the year 1908. Skramstad's liquor store and saloon is pictured on the corner at left.

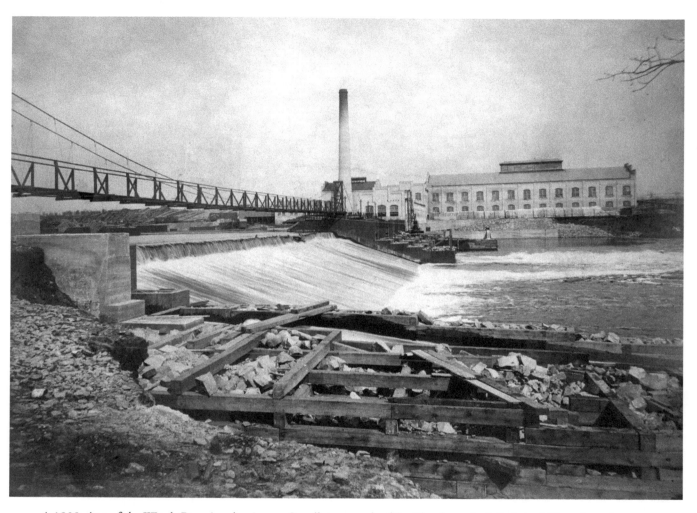

A 1908 view of the Watab Dam in what is now Sartell, just north of St. Cloud, on the Mississippi River. It took two years to build this dam, and seven people lost their lives during the construction. The dam was used to power the Watab Pulp and Paper Company, visible across the river.

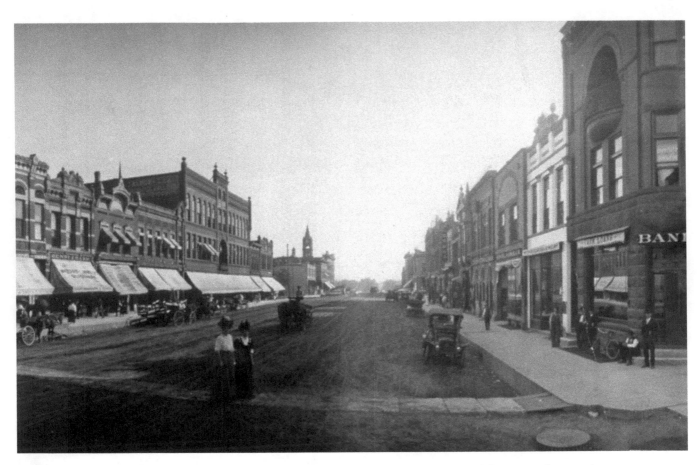

A view of downtown Albert Lea around 1908. The city is located in the southern region of the state and was an important trade center for Southeastern Minnesota and Northern Iowa. The downtown area was extensive, with grocery, hardware, and department stores, and bakeries, coffeehouses, barber shops, saloons, hotels, and restaurants.

TRANSFORMATION

(1910–1929)

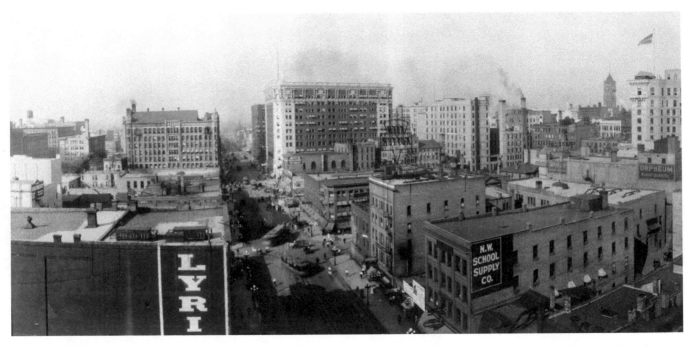

A panoramic view of downtown Minneapolis around 1911. The Lyric Theater is prominent, as is the major thoroughfare of Hennepin Avenue.

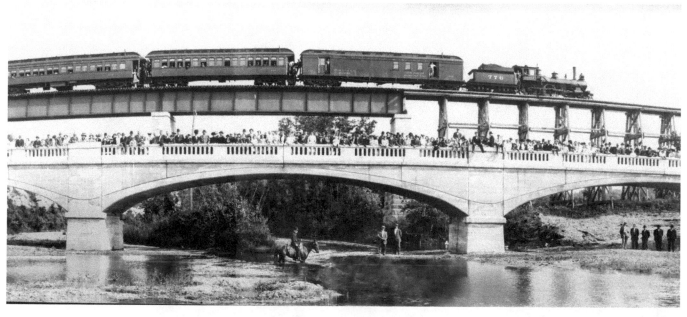

On August 2, 1911, the community of Red Jacket celebrated the opening of the Red Jacket Bridge. The new bridge was 276 feet long and 16 feet wide. A passenger train stopped for five minutes that afternoon to allow picnickers to pose for photos on the bridge below. Refreshments were provided for the cooperative train crew.

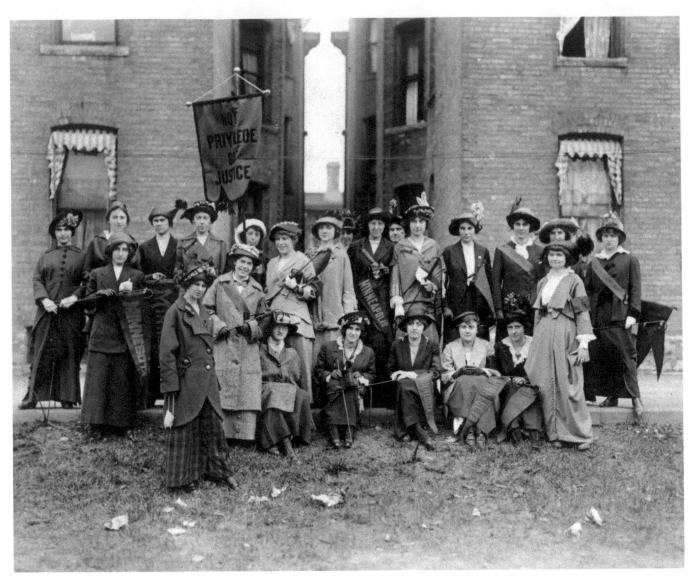

The University of Minnesota's Women's Suffrage Club, pictured in 1913, campaigned for the right to vote in United States elections. Suffragists participated in marches, rallies, speeches, and appeals to lawmakers. In 1920, women were granted the right to vote by the passage and ratification of the Nineteenth Amendment to the United States Constitution.

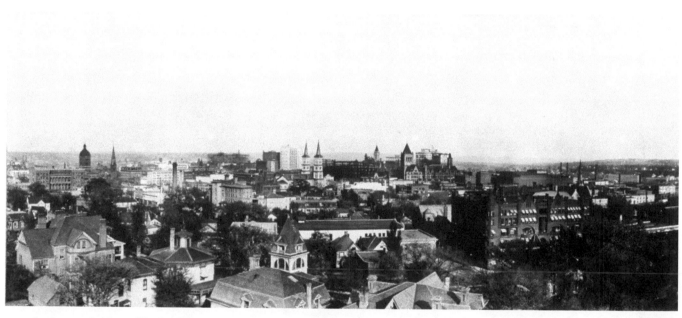

A panoramic view of St. Paul in 1915. Minnesota's third State Capitol is prominent in the distance. The first capitol building, constructed at Tenth and Cedar streets in 1853, was destroyed by fire in 1881. A second capitol, built on the same site, was deemed too small and poorly constructed. For this third capitol, legislators chose Wabasha Hill above downtown St. Paul.

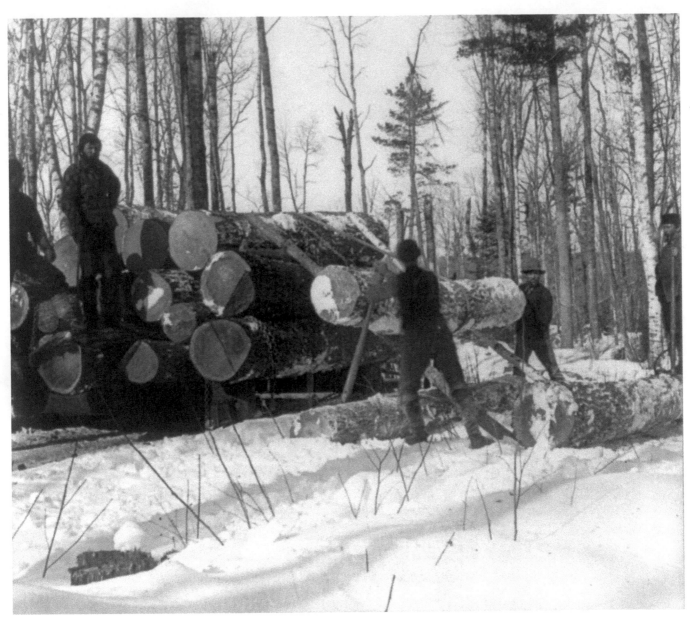

In 1915, lumberjacks use a block-and-tackle system to load felled trees onto a sleigh, to then be pulled by horses to a river or train. The work was grueling and dangerous, and many jacks were crushed trying to maneuver logs.

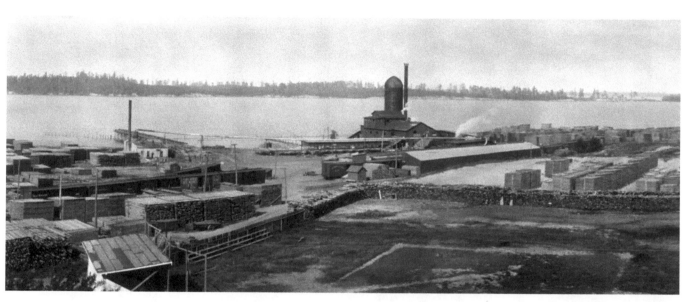

A 1915 panoramic view of the Leech Lake Lumber Company in Walker.

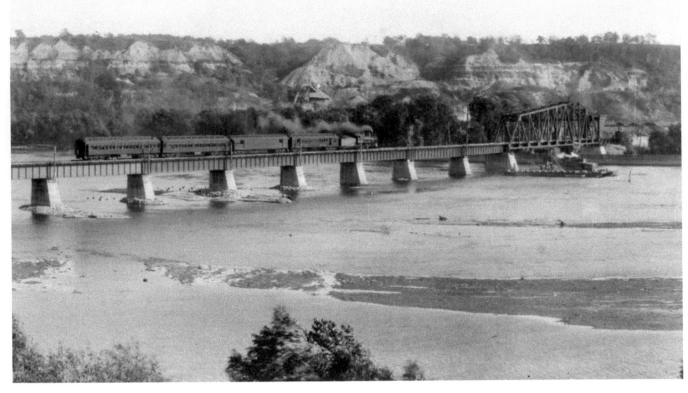

A 1916 view of a train crossing the Mississippi River at St. Paul.

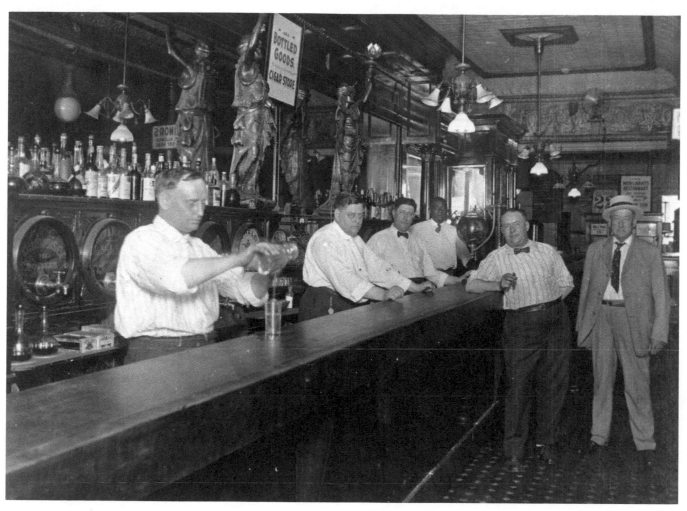

Staff bartenders, possibly at the Merchants Hotel in St. Paul, serve up "bottled goods" while they can, as Prohibition looms.

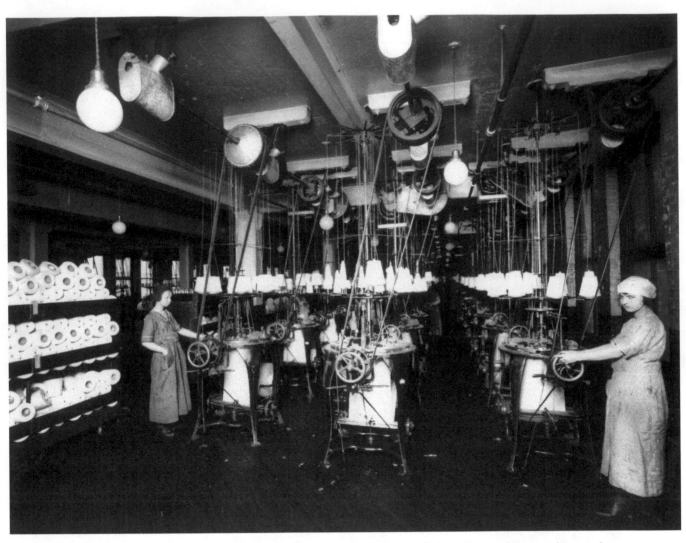

In 1920, female employees of the Munsingwear factory in Minneapolis work at the weaving machines, making underwear. The company, originally known as the Northwest Knitting Company, turned out 30,000 garments a day around the time this photo was taken. Munsingwear was also the state's largest employer of women—who made up 85 percent of the company's total workforce of 3,000 employees.

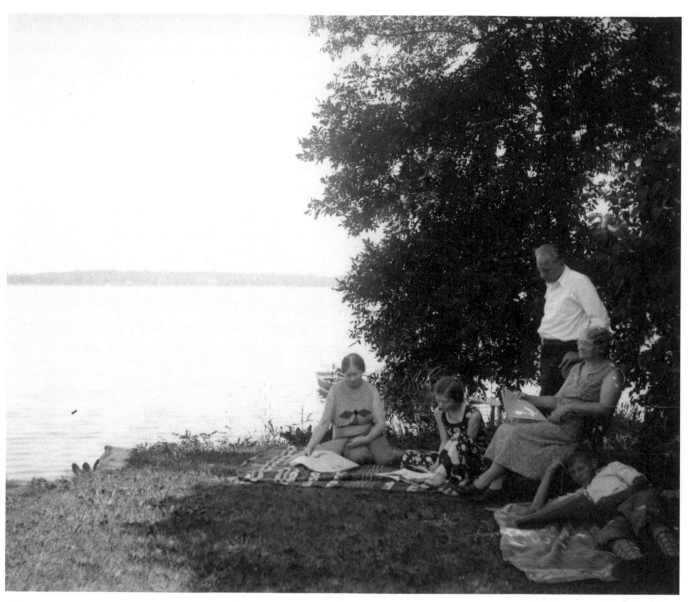

When summertime temperatures soared, Minnesotans cooled off at one of the state's many lakes, like this group did at Glen Lake in Minnetonka around 1920. While Minnesota is known to be "the land of 10,000 lakes," the actual count is 11,842.

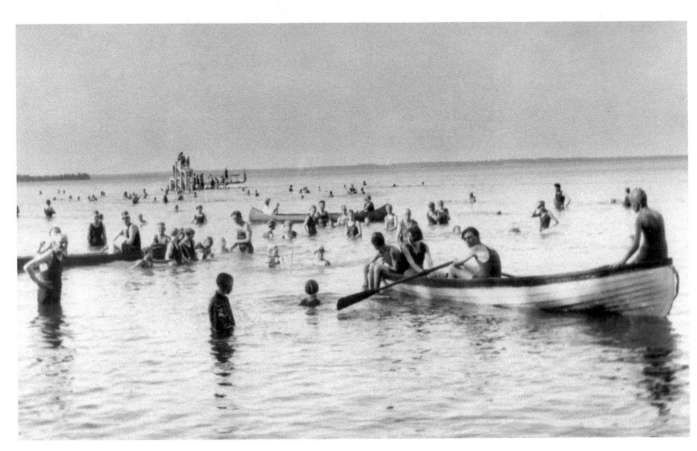

A familiar, joy-filled summertime scene at a Minnesota lake in the 1920s.

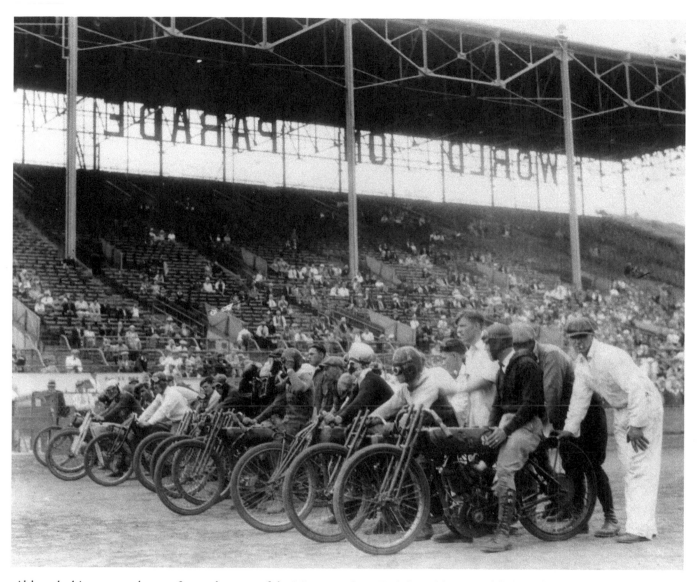

Although this motorcycle race, featured as part of the Minnesota State Fair's "World on Parade" around 1920, drew only a modest crowd, the sport was growing in popularity. In 1921, a Harley-Davidson rider became the first to win a motorcycle race with an average speed in excess of 100 miles per hour.

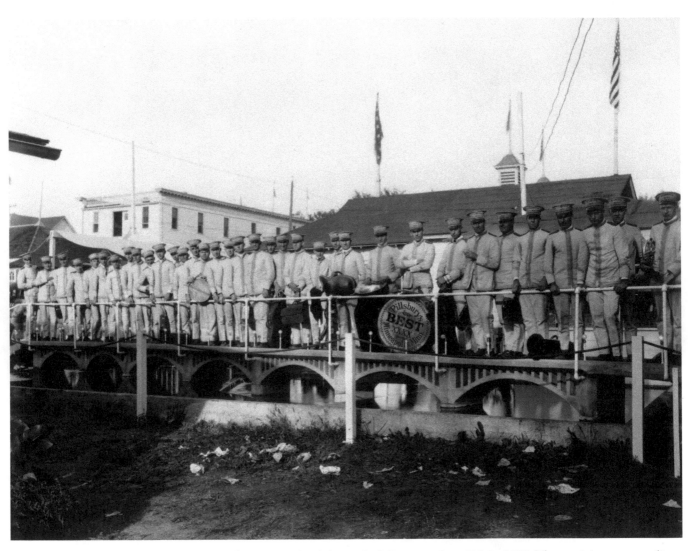

Pillsbury Company band members pose at the company's exhibit at the Minnesota State Fair in 1920. The musicians are standing on a miniature version of the Stone Arch Bridge. The bass drum advertises Pillsbury's Best Flour.

There was nothing more important to a lumberjack after 12 hours of hard, physical labor than a good meal. And the camp food was famously abundant and delicious. Lumber camp cooks such as these two were so crucial to the productivity of Minnesota camps that some earned as much as $2.50 per day—2½ times what the lumberjacks were paid.

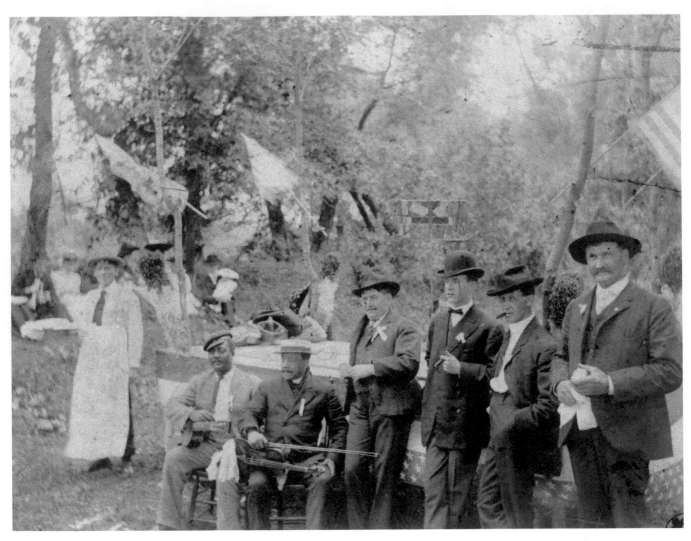

The city of Savage celebrates Independence Day around 1920 with a community picnic, complete with music. Savage is located 15 miles southwest of downtown Minneapolis. The city was originally named Hamilton, after the city in Ontario, Canada, but was renamed Savage in 1904 in honor of Marion Willis Savage, owner of the famous racehorse Dan Patch.

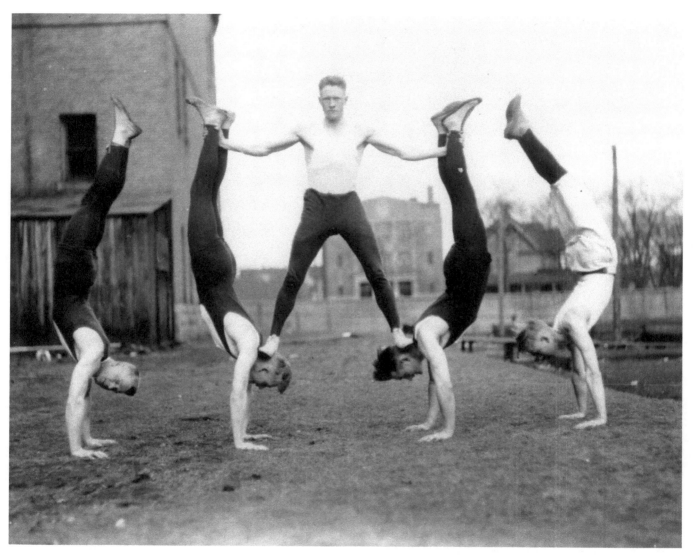

An impressive gymnastic formation and show of neck-strength, most likely by University of Minnesota students in Minneapolis, around 1920.

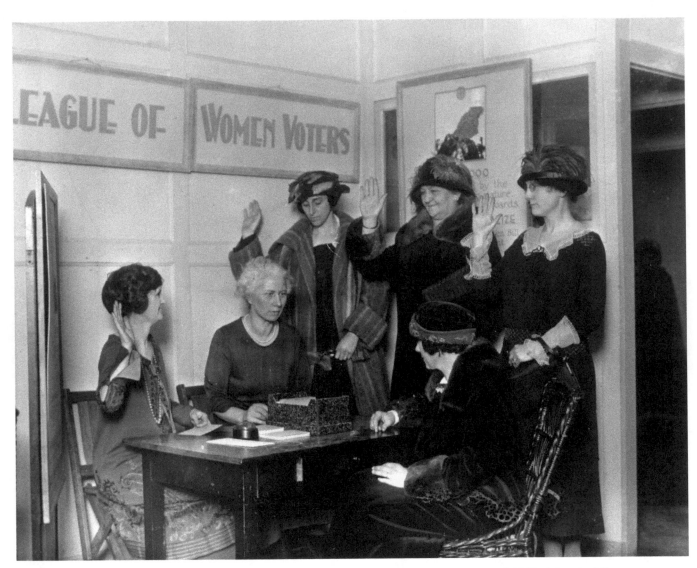

Minnesota's League of Women Voters swear in new members or register women to vote, around 1923. After the Minnesota legislature ratified the Nineteenth Amendment, granting women the right to vote, on September 8, 1919, the Minnesota Suffrage Association dissolved, becoming the Minnesota League of Women Voters. Their purpose was to "complete full enfranchisement of women and increase effectiveness of women's votes in furthering better government."

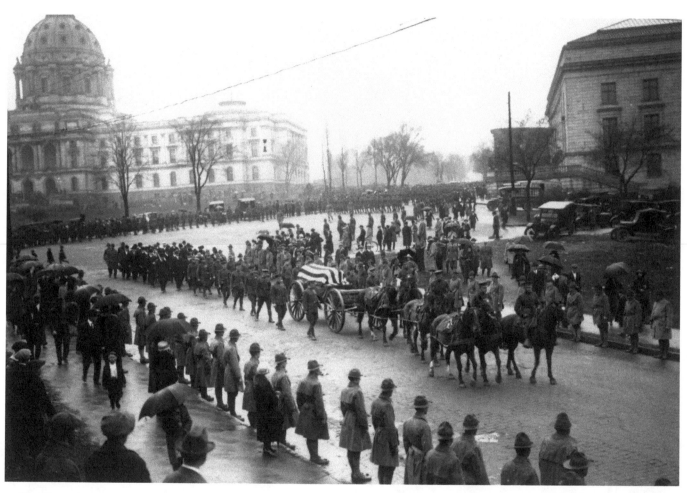

The funeral procession for politician Knute Nelson passes the former home of the Minnesota Historical Society on Cedar Street in St. Paul, May 1923. Nelson was a well-loved statesman who was born in Norway in 1842 and immigrated to Wisconsin. He was wounded and taken prisoner while serving in the Union army during the Civil War. Nelson went on to serve in the Wisconsin legislature, Minnesota legislature, U.S. House of Representatives, and U.S. Senate, and also served as governor of Minnesota.

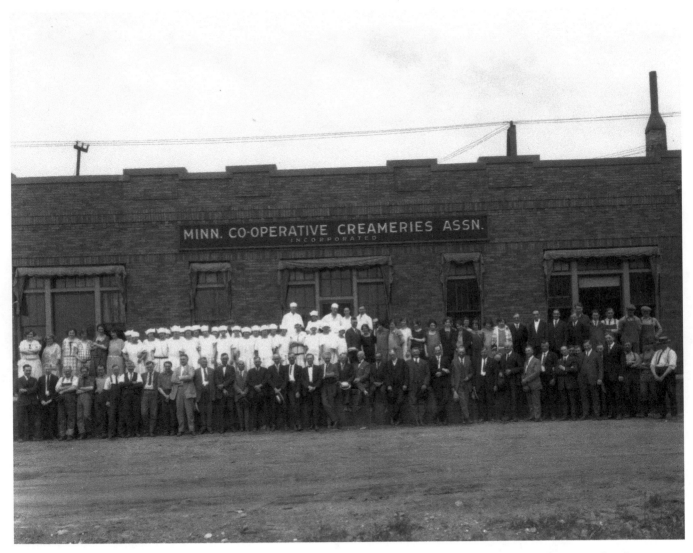

Board members, creamery workers, and other employees of the Minnesota Cooperative Creameries Association gather for a group photo in 1922. In February 1924, the cooperative announced a contest to name its butter. Two contestants tied for first place with the suggestion of "Land O'Lakes." Soon after, the company changed its name to Land O'Lakes Creameries.

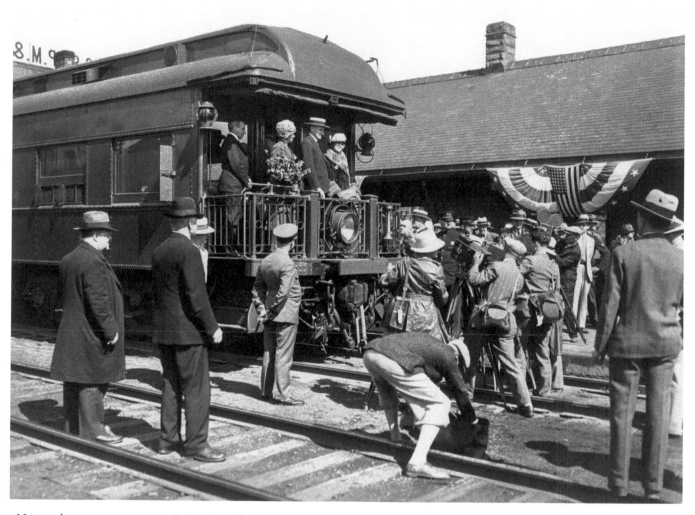

Newsreel cameramen capture Calvin Coolidge on the presidential whistle-stop campaign trail through Minnesota in 1924. When this photo was taken, Coolidge had recently lost his son to a deadly infection.

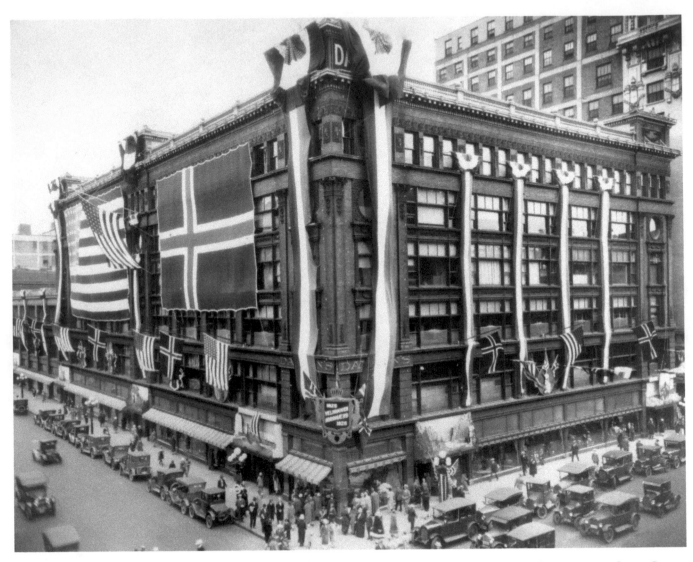

Downtown Minneapolis shoppers in 1925 gather in front of Scandinavian window displays at Dayton's Department Store. George Draper Dayton, originally a banker from Worthington, constructed this six-story building at Nicollet Avenue and Seventh Street in 1902. Dayton's Department Stores grew to be a retail icon in the Midwest.

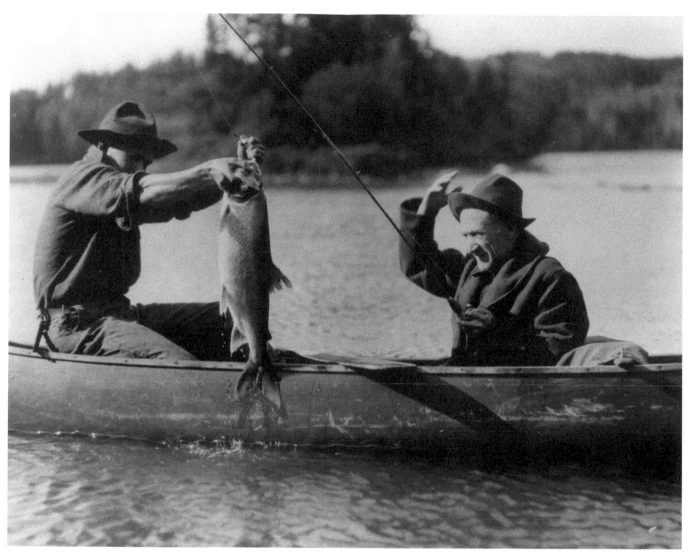

Two anglers in a canoe catch a good-sized trout from a Minnesota lake around 1925. Anglers traveled from all over the world to fish Minnesota's pristine lakes.

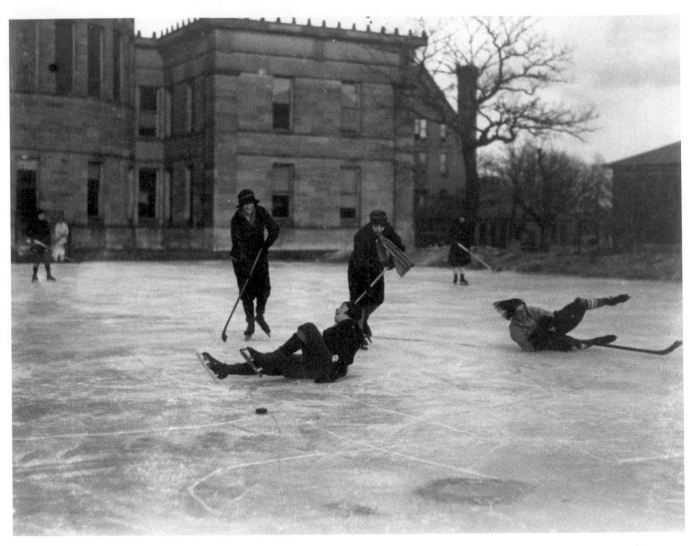

Photographed around 1925, women play hockey (and some fall trying) on a rink behind Burton Hall at the University of Minnesota's Minneapolis campus.

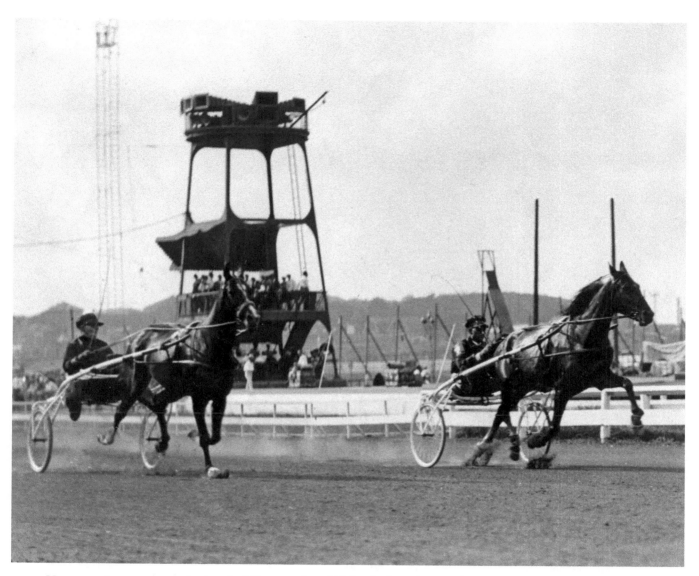

Harness racing was popularized at the Minnesota State Fair by the legendary racehorse Dan Patch, who never lost a race and set world records in the early part of the century. This photo shows harness racing at the fair in 1925. Race commentary was announced through the speakers on the judging stand. The speakers were installed by the Northwestern Bell Telephone Company and were touted to transmit a human voice five miles.

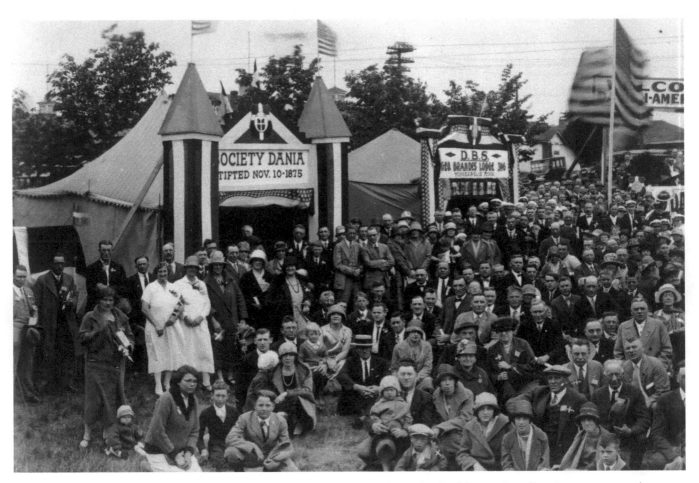

A large group poses at a Danish festival in 1926. Danish immigrants made up the third-largest Scandinavian group to settle en masse in Minnesota, behind the Swedes and Norwegians. Around the time this photo was taken, 16,904 Americans of Danish origin or descent lived in Minnesota. They settled all over the state, with large pockets in southern Minnesota.

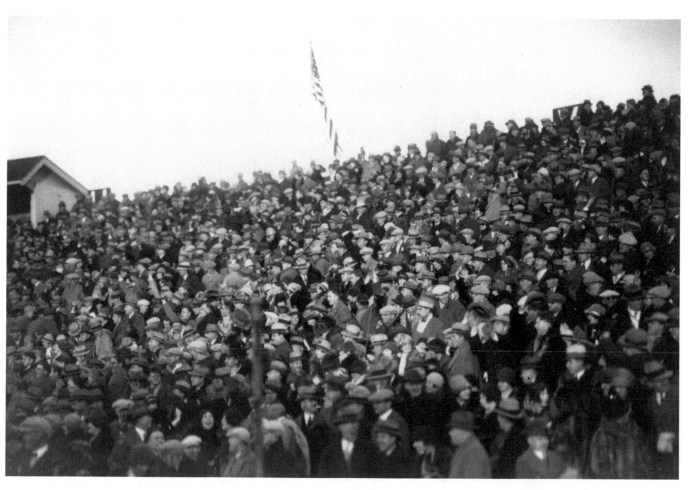

A crowd cheers on the Minnesota Golden Gophers football team at the open-air Memorial Stadium. The stadium was built in 1924 to accommodate the growing popularity of the sport in the Twin Cities.

The call of the wild was undeniable in northern Minnesota, even during trying economic times. Camping, hiking, fishing, and canoeing were great and inexpensive forms of escape.

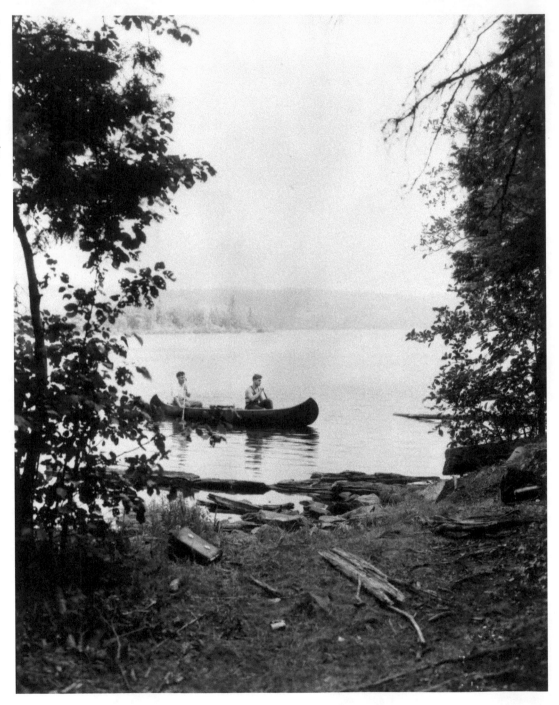

DEPRESSION AND WAR

(1930–1945)

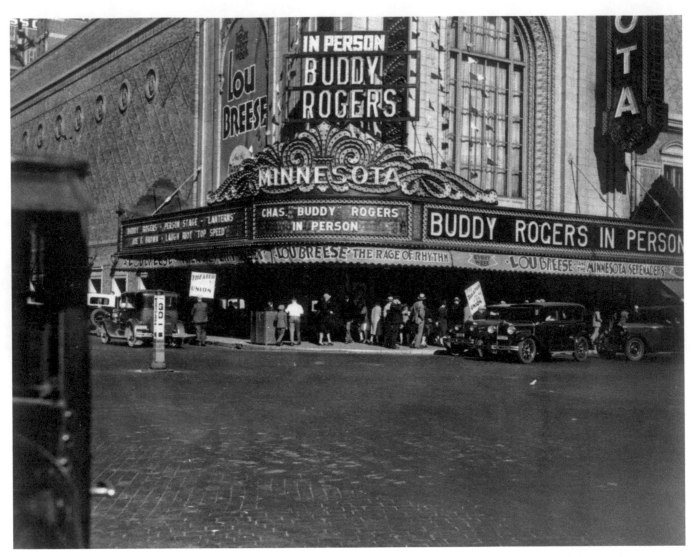

Here on September 29, 1930, the Minnesota Theater in Minneapolis is being picketed for hiring nonunion labor. Built in 1928, the 4,000-seat theater was once the fifth-largest in the country.

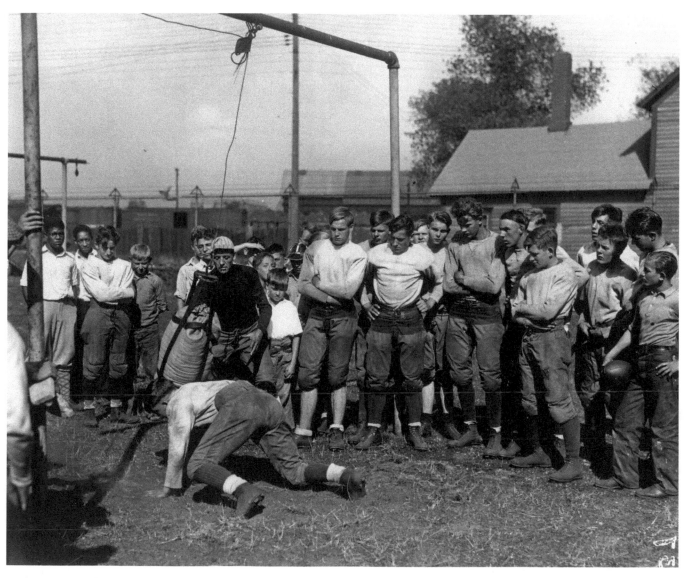

The Minneapolis South High School football team prepares for the new season in the fall of 1930. Football fever was undeniable in the Twin Cities, and many boys dreamed of becoming all-star football heroes.

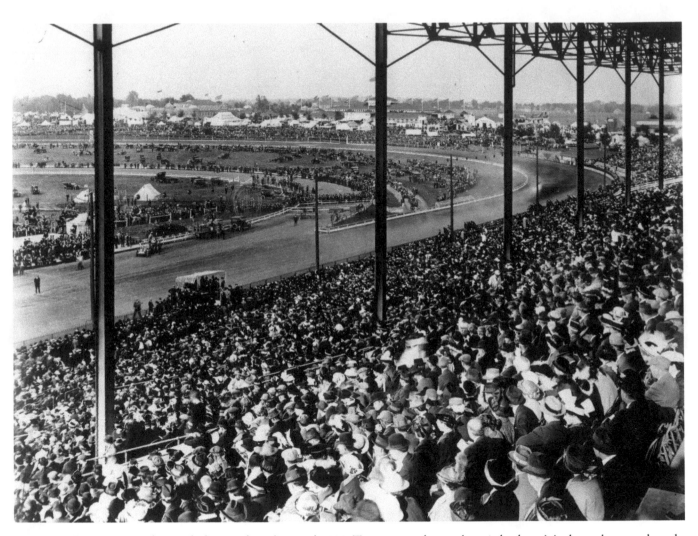

Minnesota State Fair attendees pack the grandstand around 1930. To accommodate such crowds, the original wooden grandstand was replaced in 1909 with a new brick grandstand that could seat 22,000.

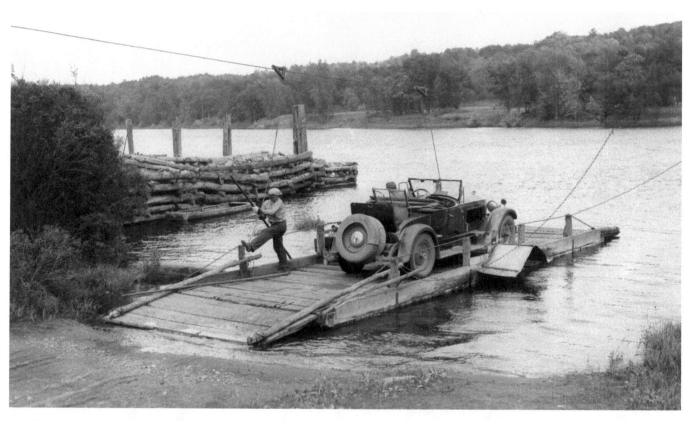

In June 1931, a man in Rush City guides a ferry carrying an automobile across the St. Croix River to Wisconsin by means of the ferry's cable system.

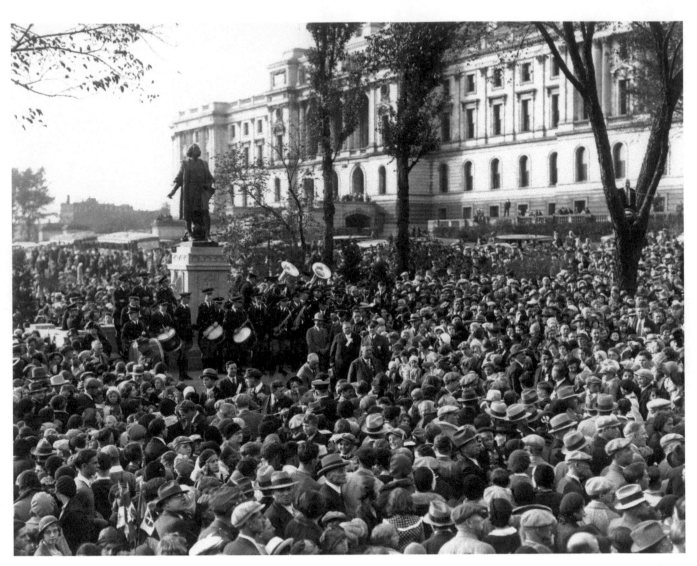

On October 12, 1931, a crowd of 25,000 gathered for the unveiling and dedication of the Christopher Columbus statue on the State Capitol grounds. The Columbus Day celebration began with a parade that made its way from Rice Park to the Capitol. The statue was a gift from the Columbus Memorial Association—a group composed of Italian societies in Minnesota.

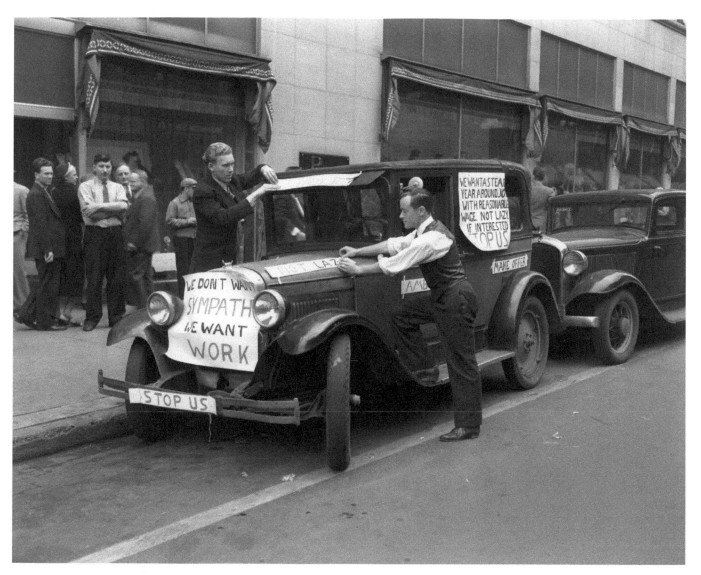

The Great Depression left millions out of work, including these two innovative Minnesota job seekers. Established in 1935, the Works Progress Administration helped alleviate some of the burden in Minnesota, as elsewhere. The WPA funded projects to improve streets, sewers, and schools. White-collar jobs also opened up—indexing newspaper articles for libraries, organizing the Health Department's birth records, updating the city assessor's plat maps, and coordinating educational programs in the arts.

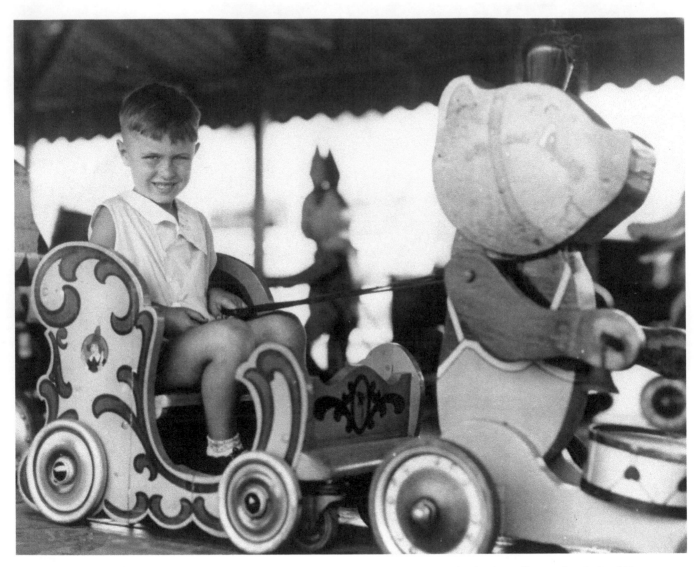

On Children's Day at the 1934 Minnesota State Fair, a boy poses on a merry-go-round ride. According to the *St. Paul Pioneer Press*, "The fair turned 75 years old in 1934 and never looked younger," due to WPA-funded projects that provided a new front grate, new buildings, new sidewalks, and extensive cosmetic improvements throughout the fairgrounds.

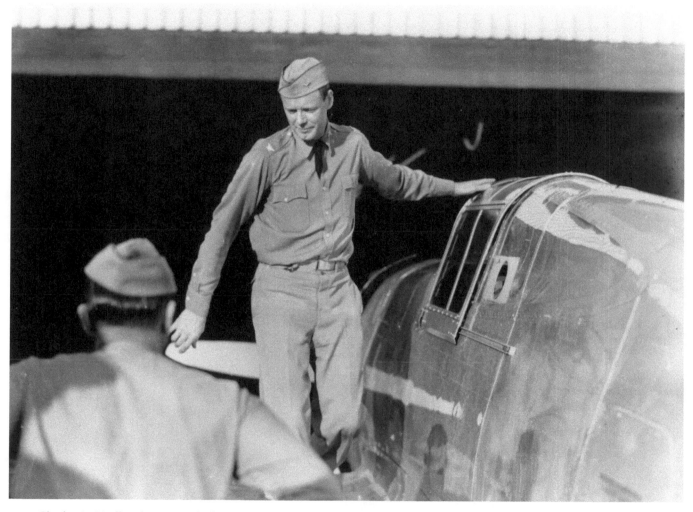

Charles A. Lindbergh visits with the men of the 109th Observation Squadron at Camp Ripley near Little Falls, around 1935. Lindbergh, famous for making the first solo nonstop flight across the Atlantic Ocean, May 20-21, 1927, grew up on a farm near Little Falls.

Two future musicians take turns trying out a baritone at the Minnesota State Fair in 1935, the first year of the fair's statewide band contest.

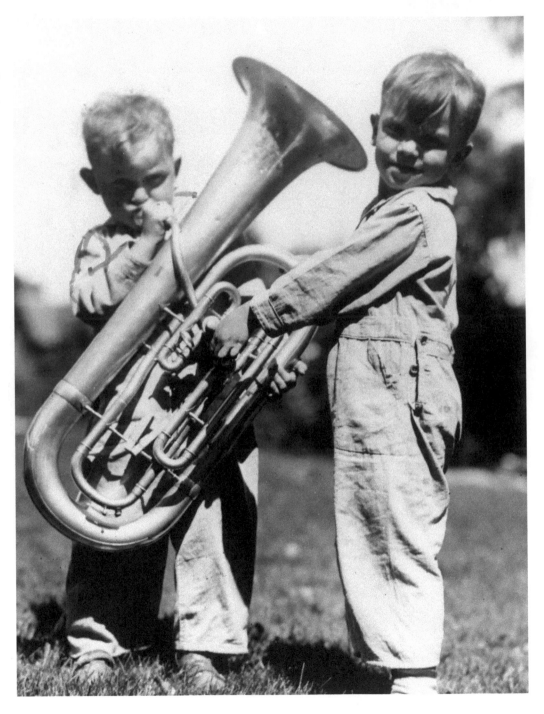

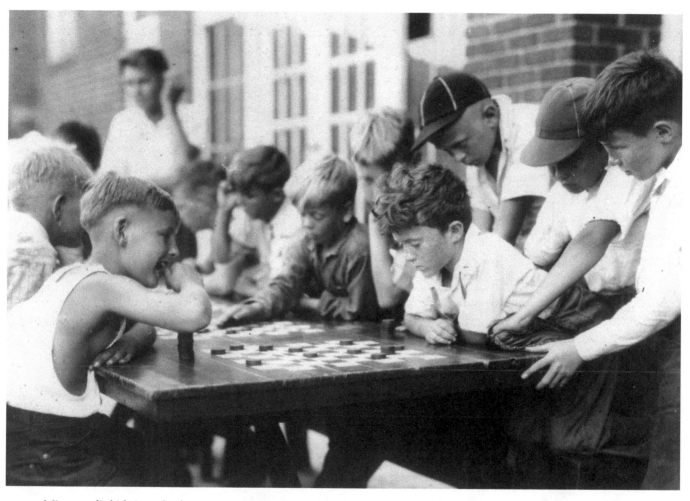

Minneapolis kids in a checkers tournament at Logan Park in 1934. The well-loved Logan Park and Community Center was central to kids growing up in this Northeast Minneapolis neighborhood. Beyond checkers tournaments, Logan Park neighborhood kids could also participate in parades, marble games, tumbling classes, plays, pageants, wood shop classes, soccer, hockey, and much more.

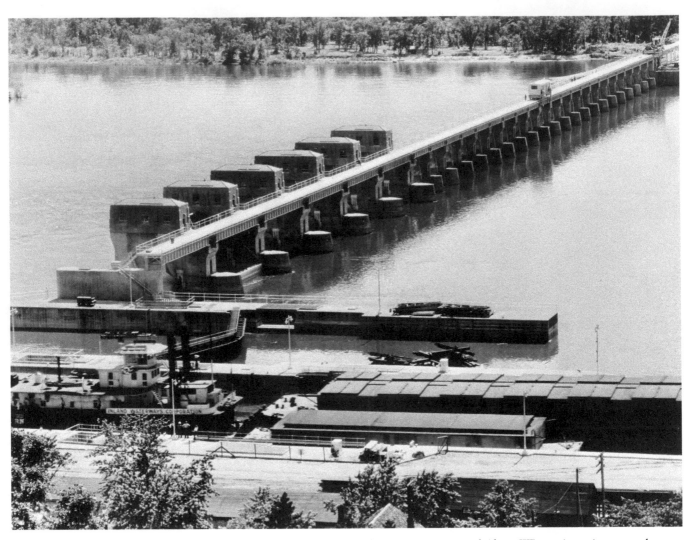

Lock and Dam Number Four on the upper Mississippi River, near Kellogg, Minnesota, and Alma, Wisconsin, as it appeared shortly after it was constructed in 1935. Building locks and dams was a dangerous affair, and several men lost their lives during construction of the facility.

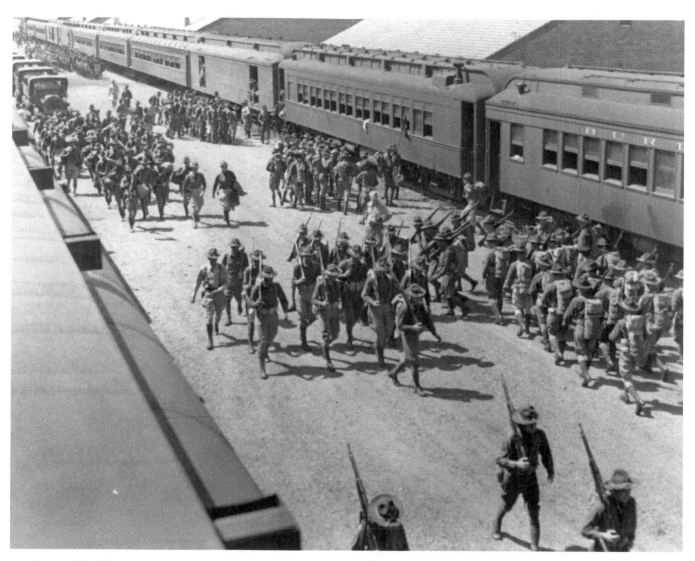

Troops debark from trains at Camp Ripley for maneuver training in August 1937. The expansion of both the regular army and National Guard prompted the need for a large-scale field-training site such as the Minnesota Army National Guard's Camp Ripley, which opened in 1931.

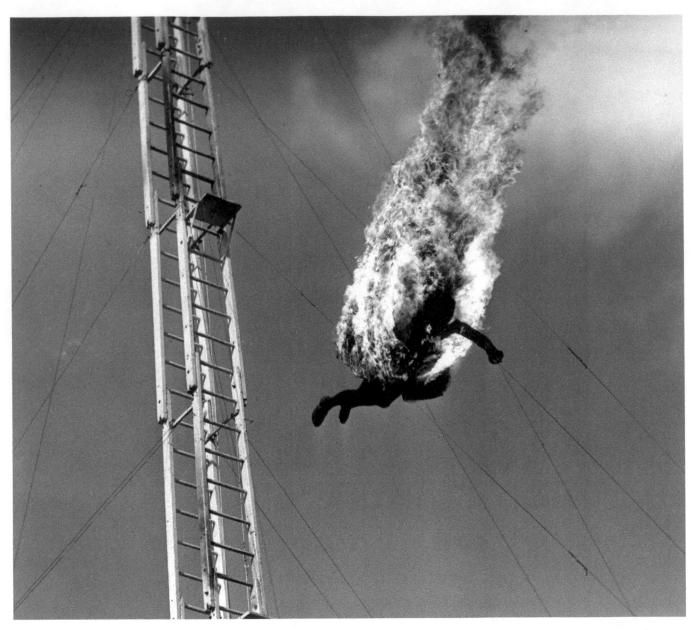

Thrill Day at the 1937 Minnesota State Fair was held on September 10 and drew record-breaking crowds. The day featured many death-defying acts, including a plane crashing into a barn on the racing track infield, an automobile crashing into a brick wall, and a diver engulfed in flames plummeting 60 feet into a water tank.

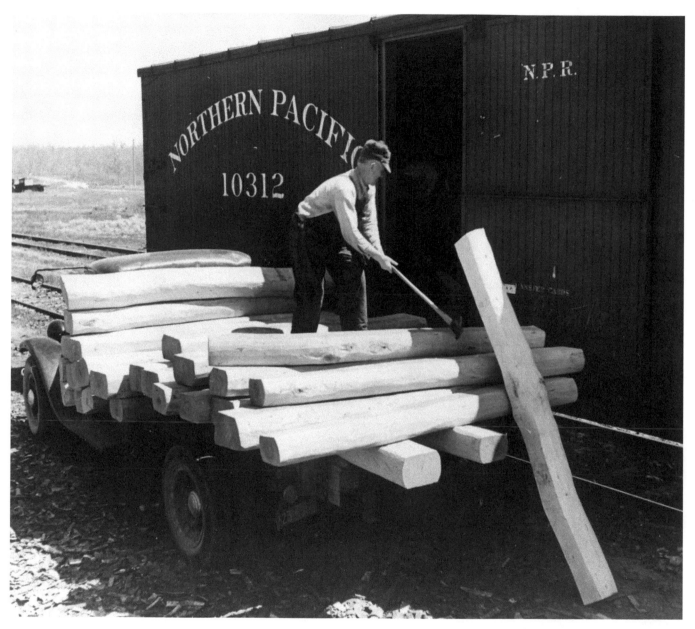

In June 1937, a man loads freshly cut railroad ties in Littlefork, near the Canadian border, as part of a Farm Security Administration program. The FSA program was originally part of a New Deal initiative to combat rural poverty by resettling poor farmers on larger group farms owned by the government.

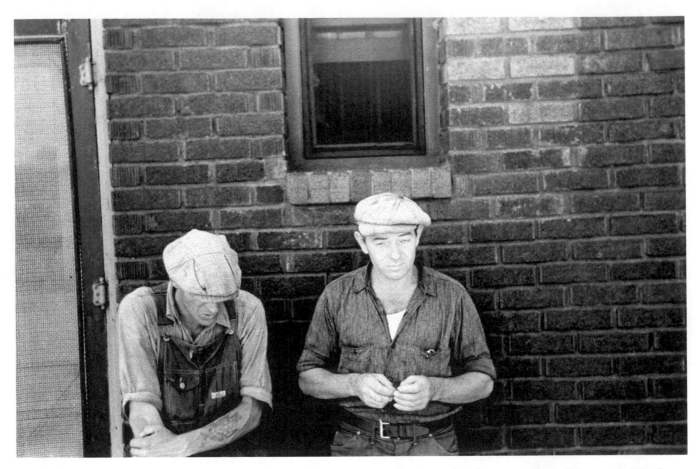

Two unemployed men in the Gateway District of Minneapolis, August 1937. Located at the convergence of Hennepin, Nicollet, and Washington avenues, the area was known for its relatively lax enforcement of vagrancy laws and as a place where day laborers could be hired. For many of the unemployed and homeless of Minneapolis, the Gateway District offered the only hope of finding any work at all.

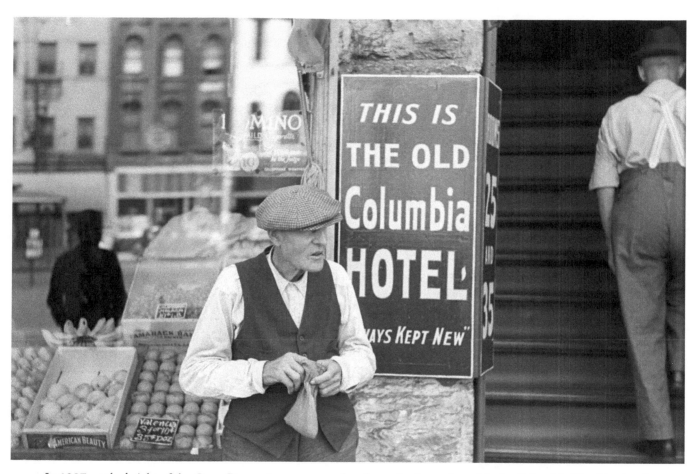

In 1937, at the height of the Great Depression, an unemployed man is pictured outside the Columbia Hotel in the Gateway District of Minneapolis.

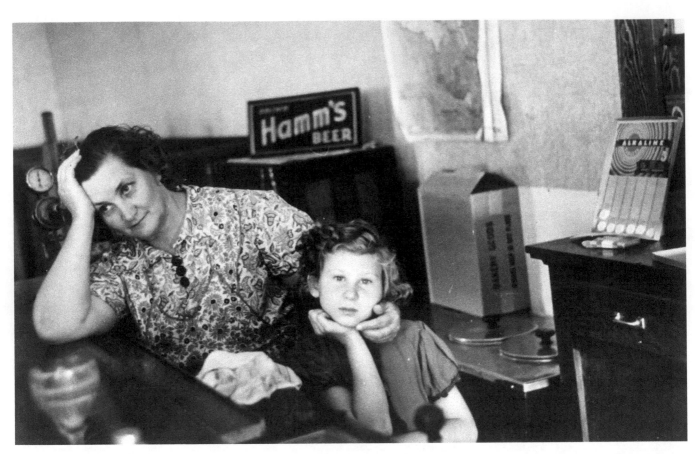

A restaurant-saloon owner and her daughter in August 1937 in Gemmell. This northern Minnesota town was once a lucrative lumber area. Gemmell was located on the Minnesota and National Railway and boasted of many hotels, shops, and restaurants. But when the forests were depleted and the work dried up, most of Gemmell closed down.

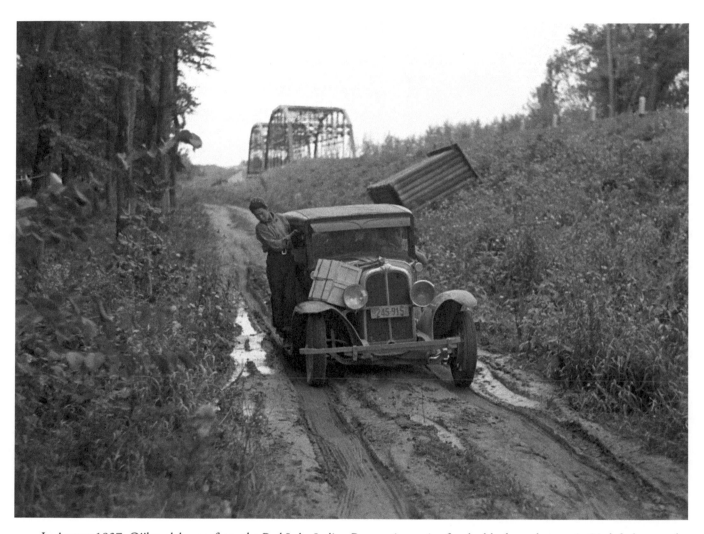

In August 1937, Ojibwe laborers from the Red Lake Indian Reservation arrive for the blueberry harvest in Littlefork, near the Canadian border. The families traveled by car and truck to previously logged areas that were giving way to impressive blueberry bush growth.

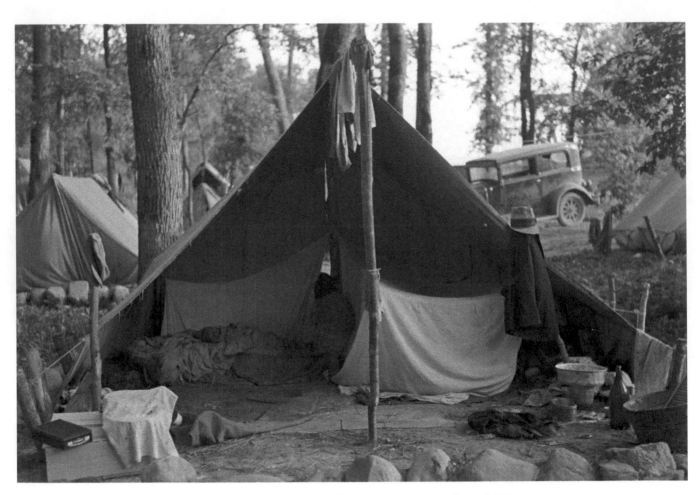

The Ojibwe blueberry pickers in 1937 camped on the north side of a river, just outside Littlefork.

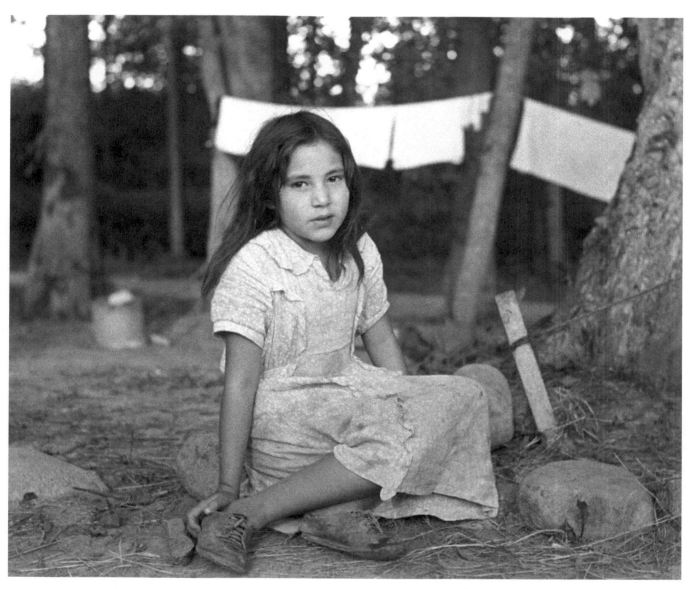

A daughter of an Ojibwe blueberry picker at their campsite near the harvest area. The pickers filled crates with blueberries and sold them for ten cents a quart to local merchants, who in turn shipped the berries by train to city markets.

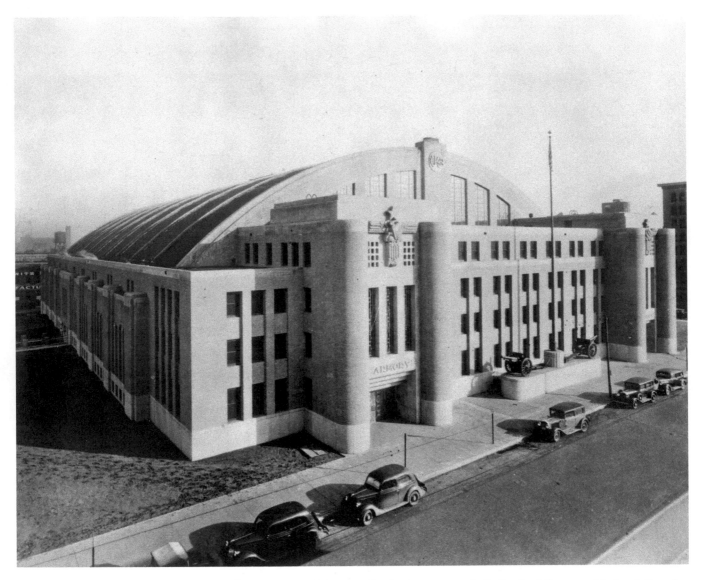

The Minneapolis Armory in 1939. Located in downtown Minneapolis, the Armory was built for the Minnesota National Guard with the aid of a grant from the Public Works Administration in 1936. At a cost of $793,000, it was the single most expensive PWA project in Minnesota. Later, the building was used for civic events and as a home court for the Minneapolis Lakers basketball team.

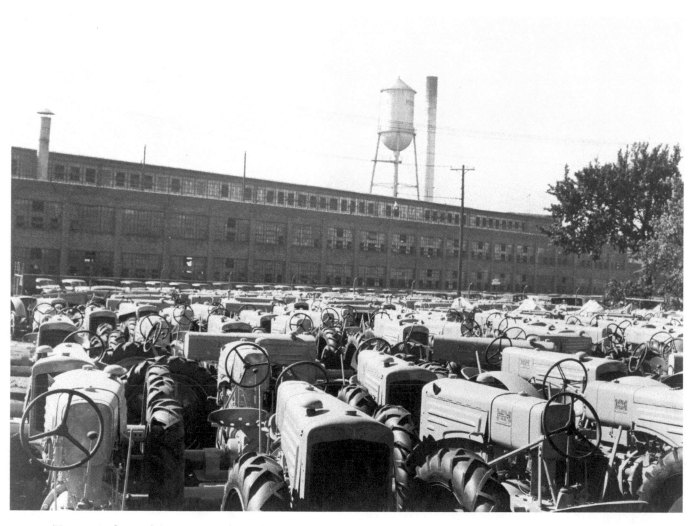

Tractors in front of the Minneapolis-Moline Company, a large tractor and machinery producer, in September 1939. Three companies—Minneapolis Steel & Machinery, Minneapolis Threshing Machine, and Moline Plow—merged in 1929 to form Minneapolis-Moline. The headquarters and a plant were located in Hopkins, with additional plants in Moline, Illinois, and on Lake Street in Minneapolis.

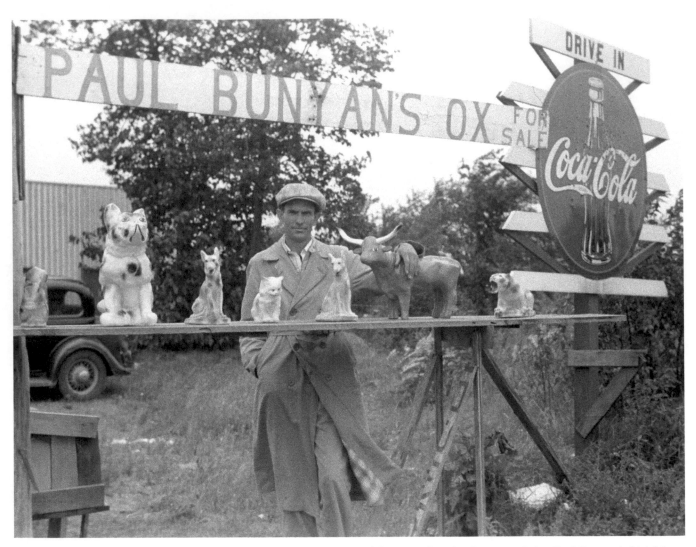

A roadside vendor near Bemidji in 1939, displaying samples of animal figurines for sale, showcases Babe, Paul Bunyan's faithful ox. According to legend, Minnesota's lakes were formed when Paul and Babe stomped across the state. Paul found Babe wandering around, lost and cold amid the snowdrifts of the "Winter of Blue Snow." Babe was so cold that he turned blue like the snow and stayed that way even after warming up.

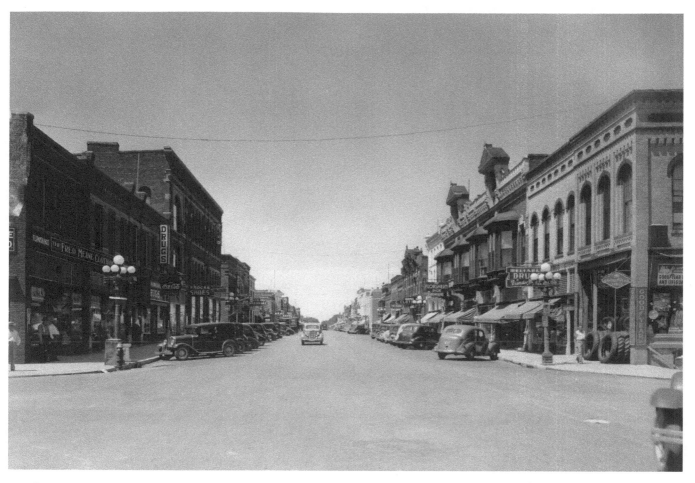

The Minnesota Street business district in New Ulm, around 1940. While business was slow all over New Ulm during the Great Depression, in 1940 the city's creamery industry reported significant gains.

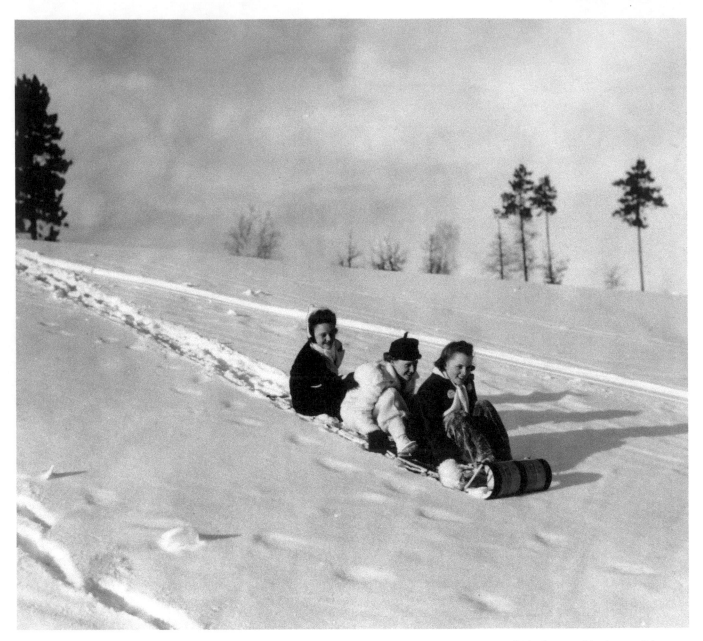

Three girls toboggan down a snow-covered hill in Minnesota around 1940. For most Minnesota kids, long, cold winters did not signal the end of outdoor fun. Kids of all ages enjoyed snowshoeing, skiing, ice-skating, sledding, and occasional snowball fights mixed with making snow angels.

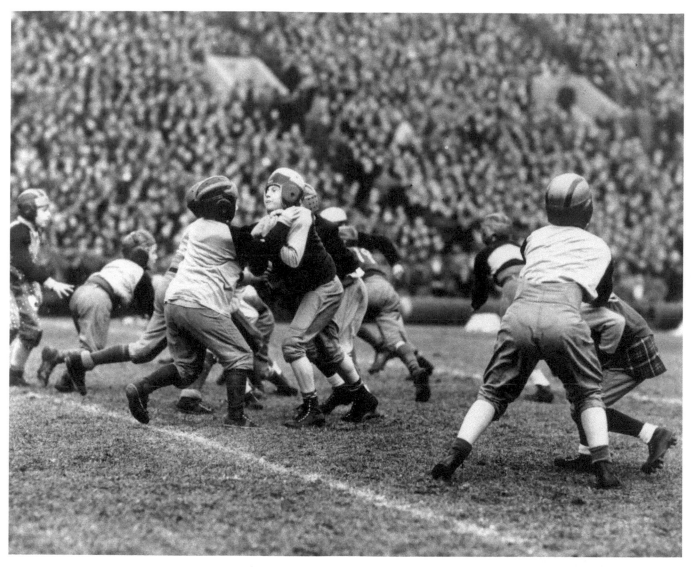

Two youth football teams got the opportunity to play for a University of Minnesota Gophers football crowd as the halftime show during a Memorial Stadium game in the 1940s.

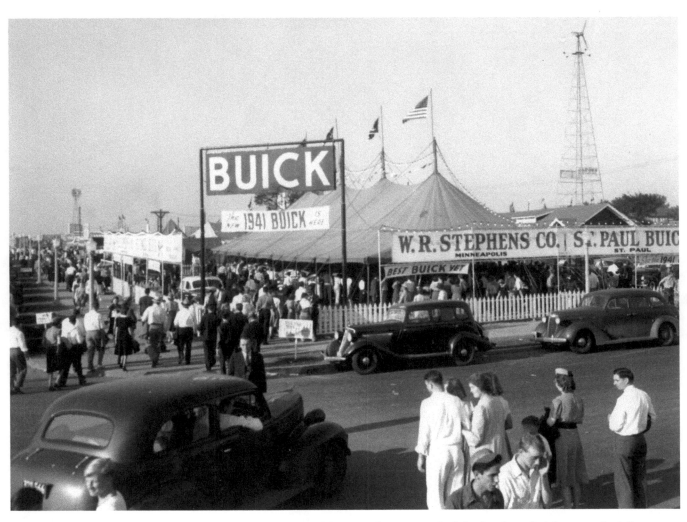

In 1941, a few months before the United States entered World War II, fairgoers packed the Stephens Buick tent at the Minnesota State Fair. The average cost for a Buick at that time was around $1,314. The admission price to the fair had dropped to 25¢.

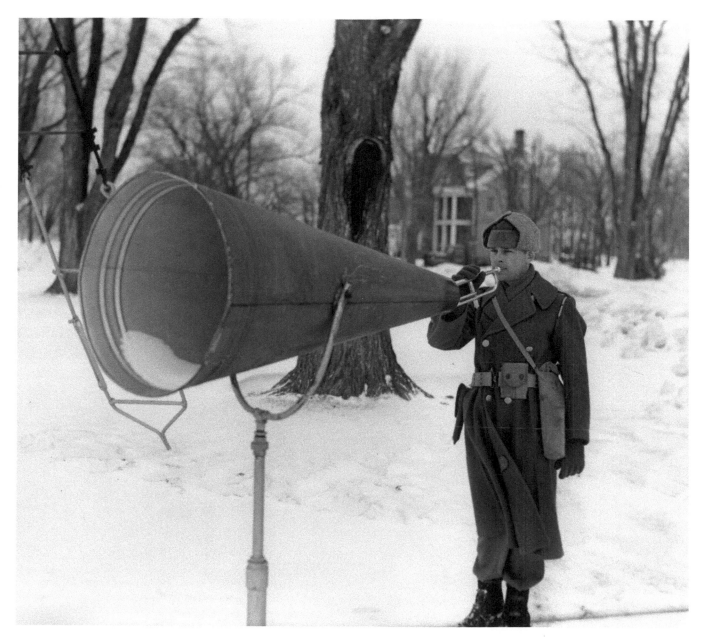

A soldier at Fort Snelling during the winter of 1941 plays a bugle into a mammoth megaphone. During the war, Fort Snelling served as an important reception center for newly drafted recruits, who were tested to determine physical and mental fitness before being assigned to training camps. In total, 300,000 recruits were processed through Fort Snelling during the war years.

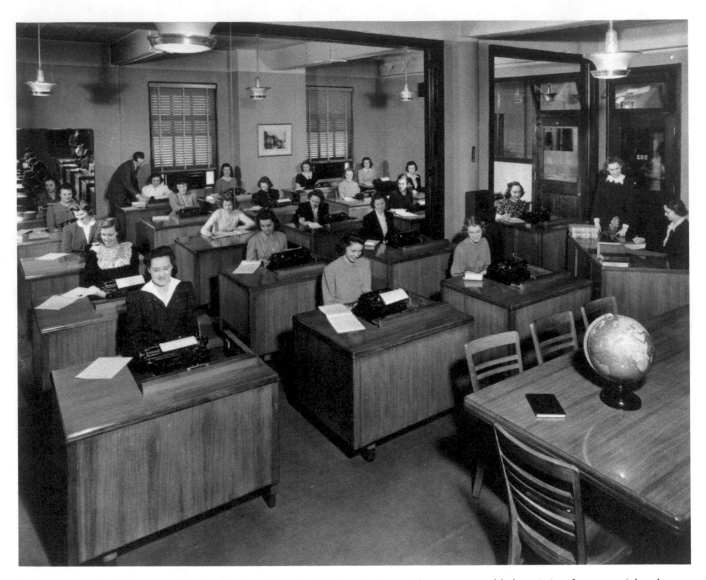

A classroom at the Minnesota School of Business in Richfield in May 1941. The women are likely training for secretarial and bookkeeping positions. Professor Alexander R. Archibald, formerly of Dartmouth College, founded the school in 1877. The school's first location was a three-room building at Third and Marquette in Minneapolis, where Professor Archibald taught bookkeeping, shorthand, English, and penmanship.

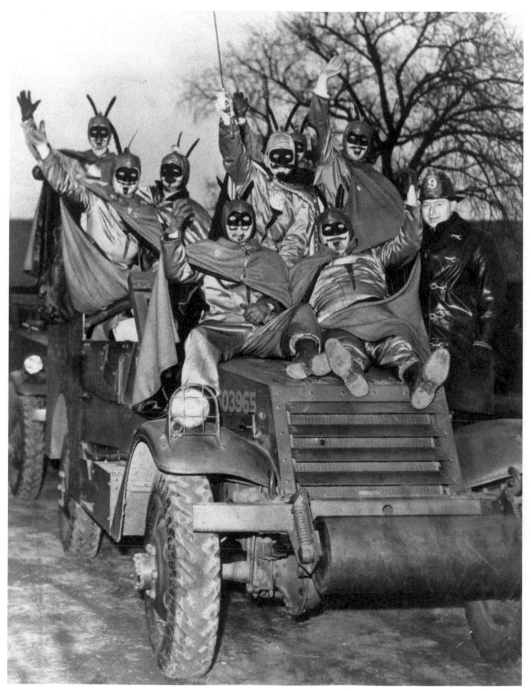

Vulcan Rex VIII, his Vulcan Krewe, and a firefighter in the St. Paul Winter Carnival parade in 1942. The Vulcans have a long history of mischief-making and mythic battling, dating to St. Paul's first Winter Carnival in 1886. Originally, there was just one Vulcan, known as the Fire King, who battled King Boreas and his royal family throughout the carnival. But in 1940, Vulcan Rex VI recruited friends, and the rest is history.

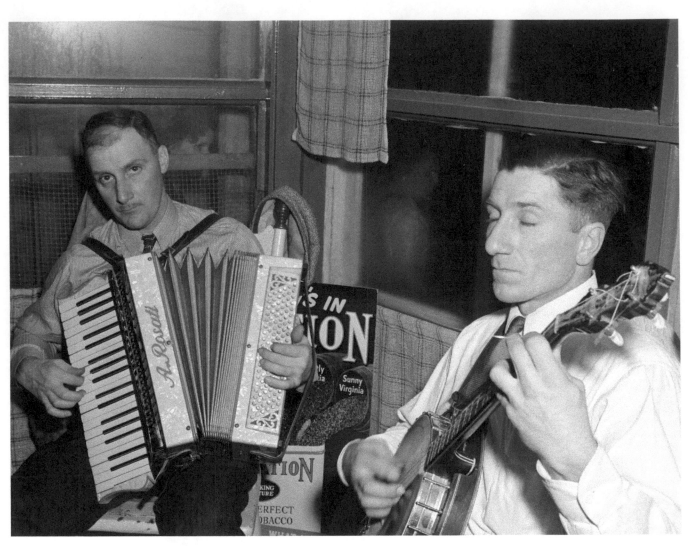

Wielding accordion and banjo, two Meeker County farmers supply the music for a dance at a crossroads store in February 1942.

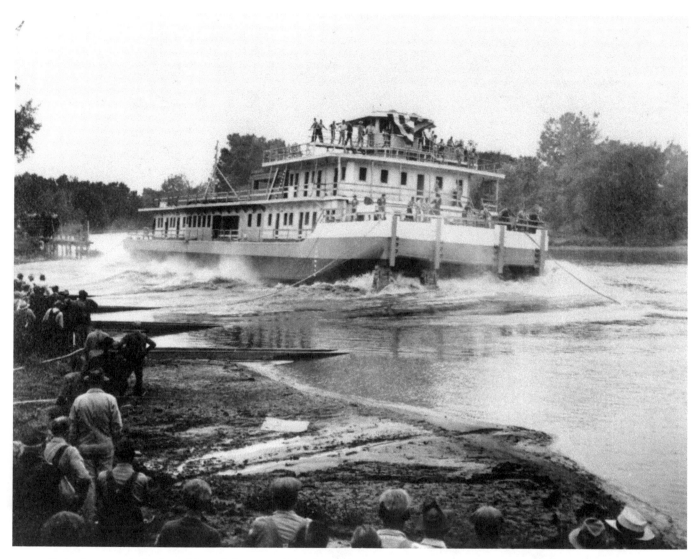

Onlookers watch the launching of *Quarter* at Port Cargill in Savage. In 1942, Cargill Incorporated contracted with the U.S. Navy to build six ocean-going tankers. The company constructed Meadowland Shipyard and changed the name of Hamilton Landing to Port Cargill. To launch the ships, 14 miles of the Minnesota River were dredged from Savage to the Mississippi River confluence. About 3,500 people were employed during peak production, resulting in construction of 18 auxiliary oil and gas carriers, and 4 tugboats.

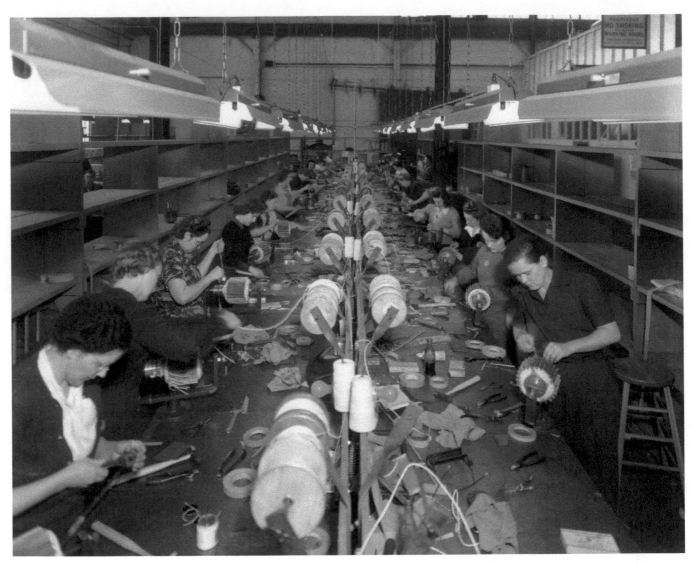

The wartime increase in production and the shortage of male labor meant that employers had to recruit and train women for positions traditionally filled by men. These wartime workers are winding armatures at the D. W. Onan and Sons plant near the University of Minnesota.

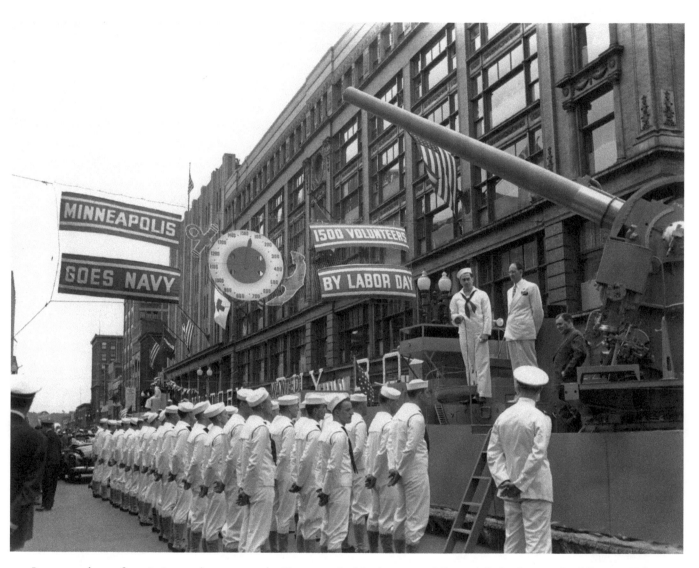

In a great show of patriotism and pageantry, the Navy recruited in downtown Minneapolis in the months following U.S. entry into World War II.

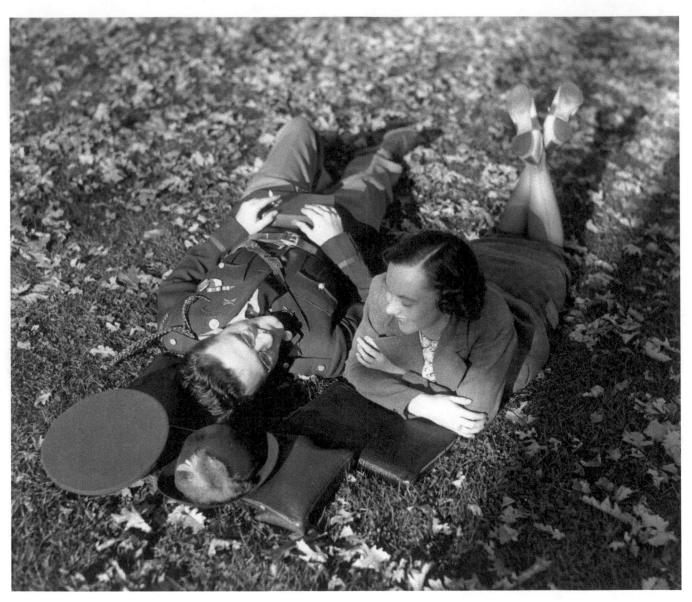

The quintessential image of a World War II soldier and his "gal back home." The soldier, on leave, is home in Minnesota for a short visit.

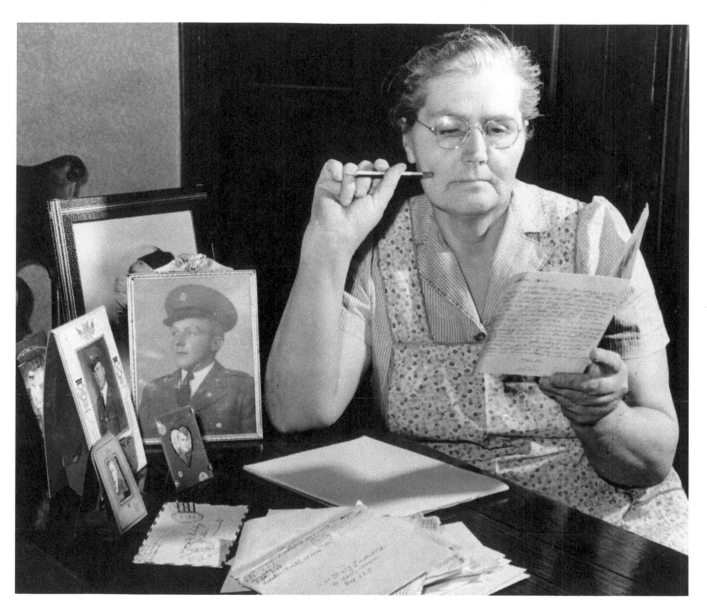

A Minnesota mother sits and reads a letter from her son who is fighting overseas in 1943.

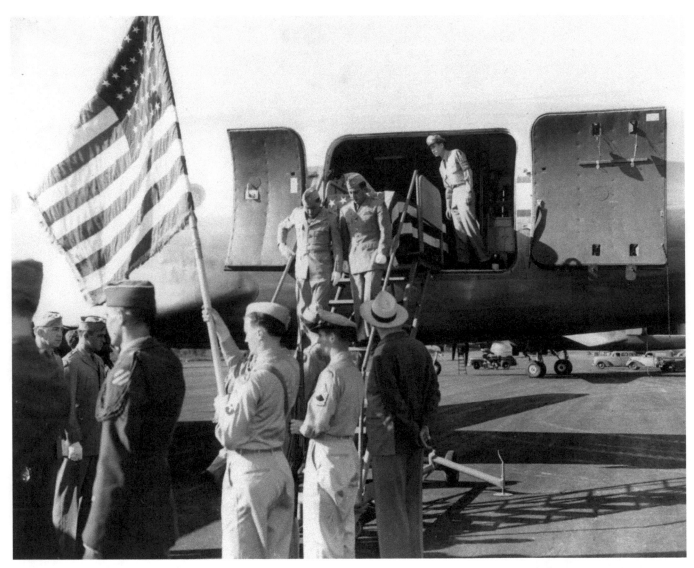

In August 1945, the body of Major Richard Bong, a World War II Medal of Honor recipient, was flown to Duluth to be buried in nearby Poplar, Wisconsin. A Wisconsin native, Bong shot down at least 40 Japanese planes during World War II, making him the United States' highest-scoring air ace. He died during a test flight in Burbank, California, when the plane's fuel pump malfunctioned.

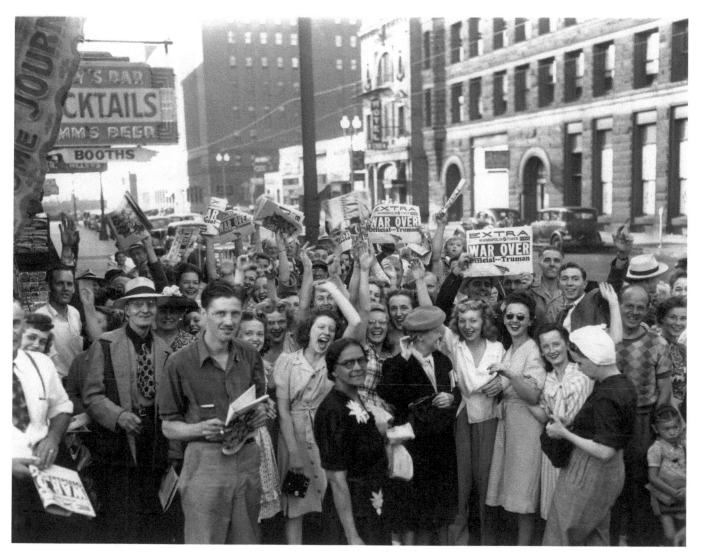

With newspapers held aloft, a crowd in downtown Minneapolis celebrates victory over Japan and the end of World War II on August 15, 1945. All across the state, Minnesotans celebrated V-J Day with singing, drinking, and dancing. Some celebrations in the downtowns of the Twin Cities spanned several days and nights.

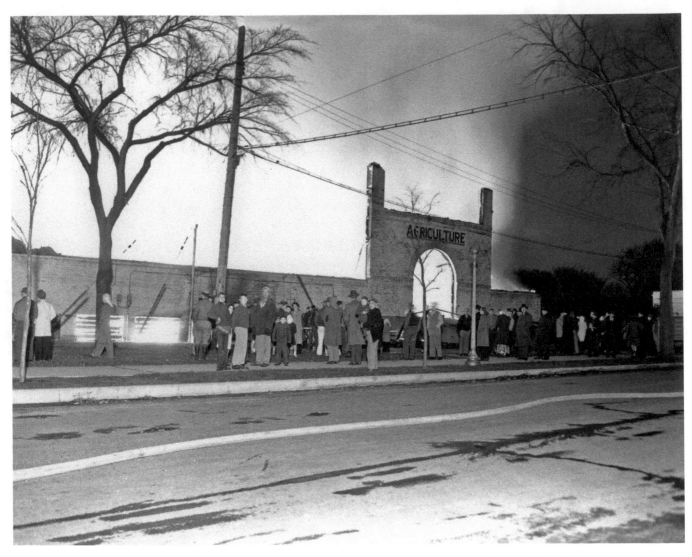

On November 10, 1944, crowds turn out to watch the fire department attempt to put out a fire engulfing the Agriculture Building on the Minnesota State Fairgrounds. The fire completely destroyed the building. Built in 1885, the Agriculture Building was the first structure on the fairgrounds.

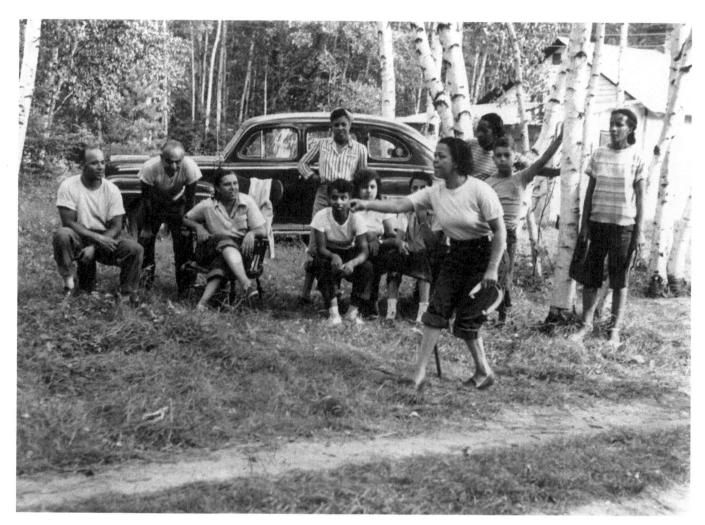

Minnesota families play horseshoes at a Twin Cities Reel and Trigger Club picnic on Labor Day in 1945.

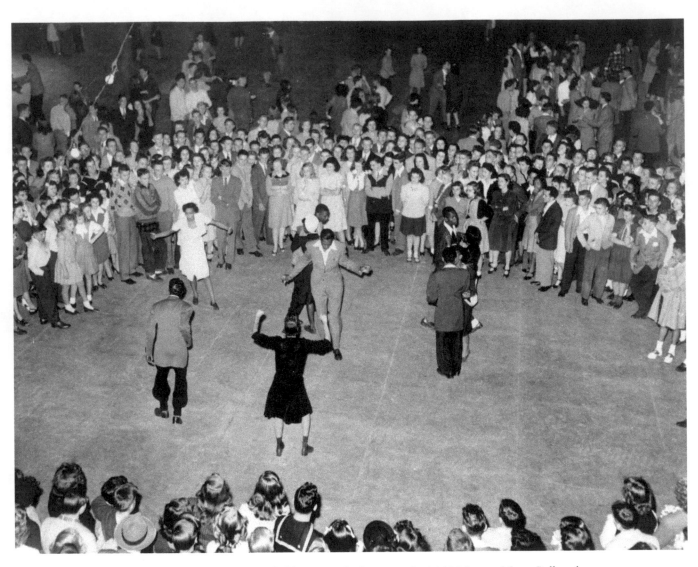

Several couples demonstrate the jitterbug surrounded by a crowd of teens at the 1945 Harvest Moon Ball at the St. Paul Auditorium.

Modern Minnesota

(1946–1950s)

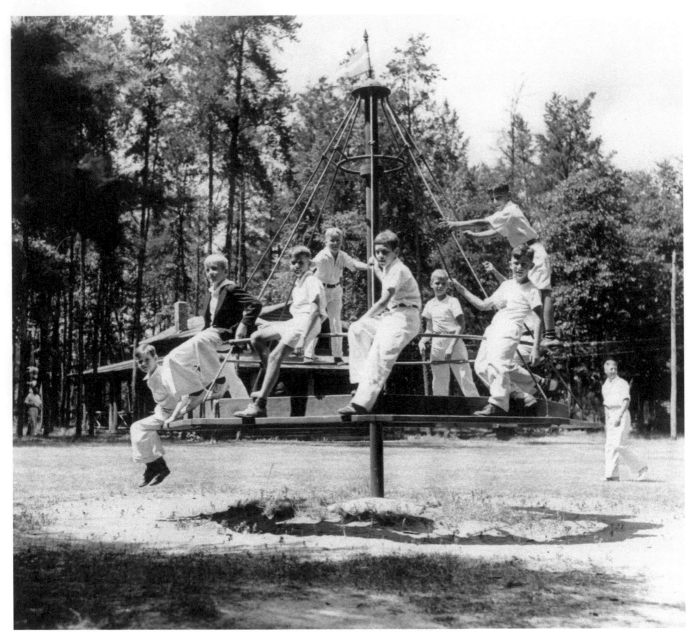

After the war, life began anew. Children born before or during the war enjoy the playground equipment at a northern Minnesota resort.

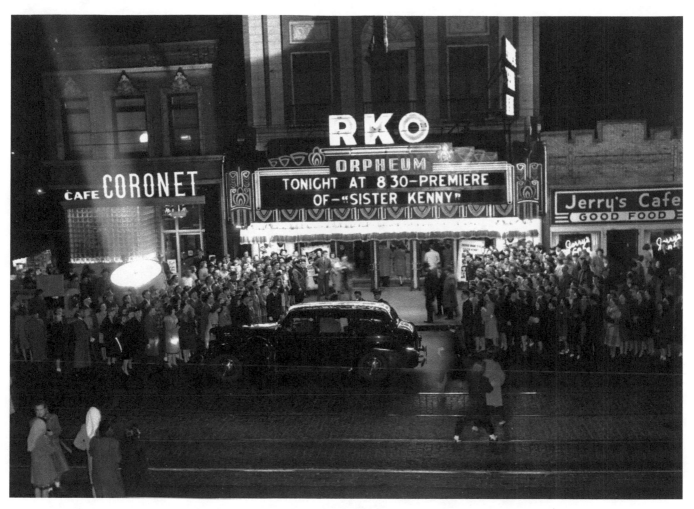

The premiere of the film *Sister Kenny* at the Orpheum Theater in Minneapolis in 1946. The movie was based on the life of Sister Elizabeth Kenny, who discovered a revolutionary treatment for infantile paralysis. She came from Australia to Minnesota in 1940 and established the Sister Kenny Institute, which opened its doors in Minneapolis in 1942. Rosalind Russell portrayed her in the film.

The Christmas tree in the governor's office reception room at the Minnesota State Capitol is decorated in 1946. Edward J. Thye's tenure as governor was about to end, with Luther W. Youngdahl prepared to take office on January 8, 1947.

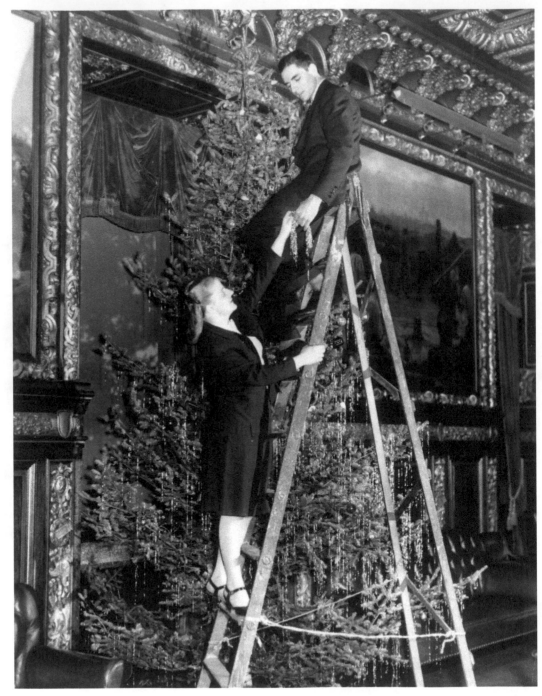

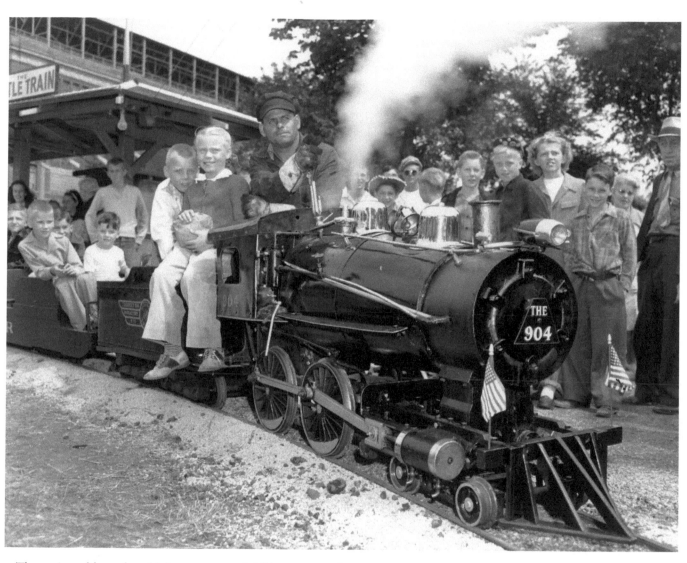

The engineer blows the whistle as a group of children prepare for an excursion on the popular Little Train at the Minnesota State Fair in 1947.

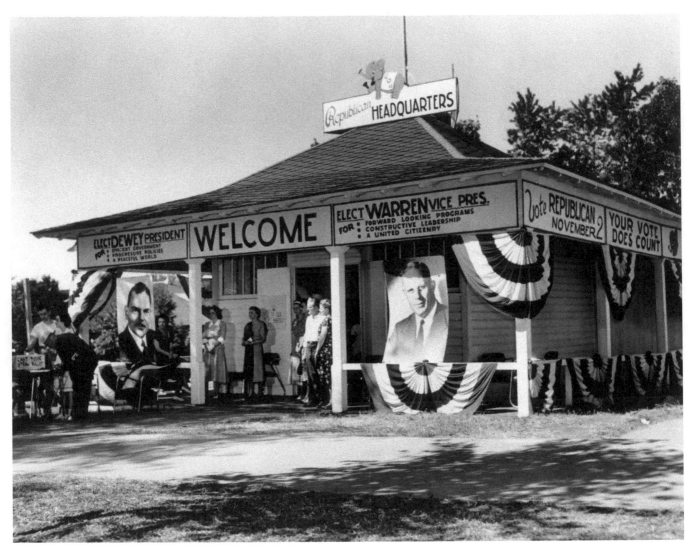

Republican headquarters for the Dewey-Warren ticket in 1948 at the Minnesota State Fair. From the early days, politicians were at home at the fair, campaigning and delivering speeches. Two presidents, Coolidge and Hayes, spoke to packed crowds at the grandstand, and Vice-president Theodore Roosevelt introduced his famous line "Speak softly and carry a big stick" at the fair in September 1901. Less than two weeks later, President McKinley was assassinated and Roosevelt became president.

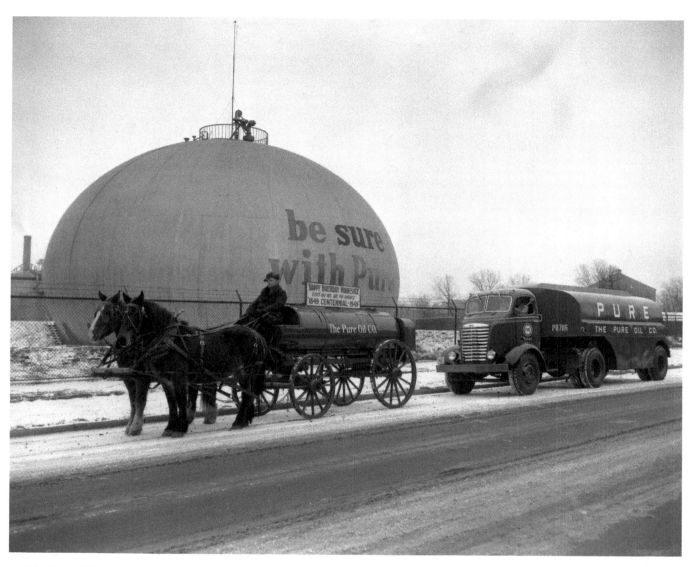

The Pure Oil Company kicks off celebration of the Minnesota Territory Centennial on December 31, 1949, with two modes of transportation, symbolic of how much Minnesota had changed in 100 years.

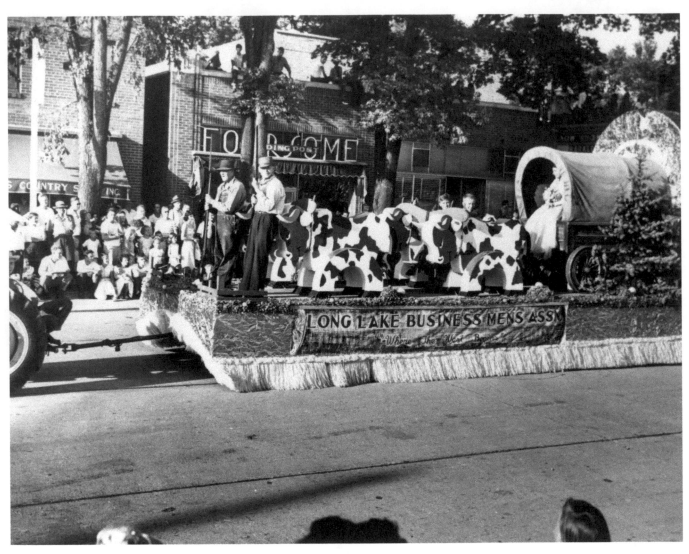

The Long Lake Business Men's Association float parades through Wayzata during the Minnesota Territory Centennial celebration in 1949. Some of the best parade viewing was from the rooftops of this Lake Minnetonka destination.

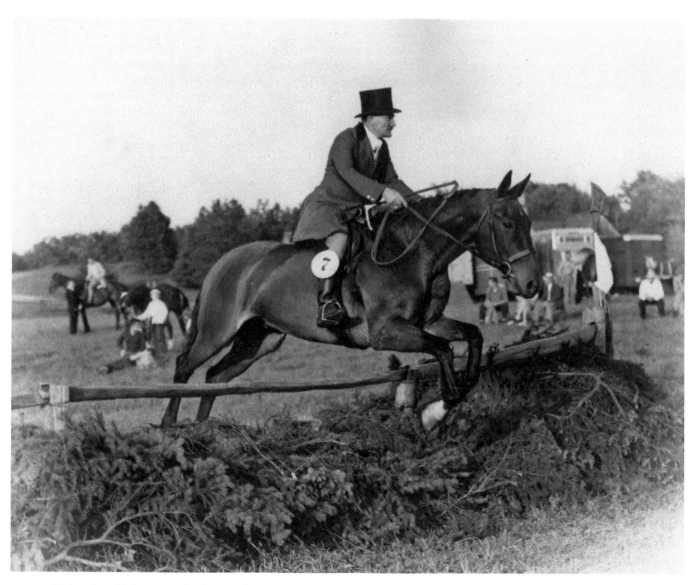

University of Minnesota faculty member Colonel Ralph M. Bitler and his horse Sun Valley compete in an equestrian event around 1949.

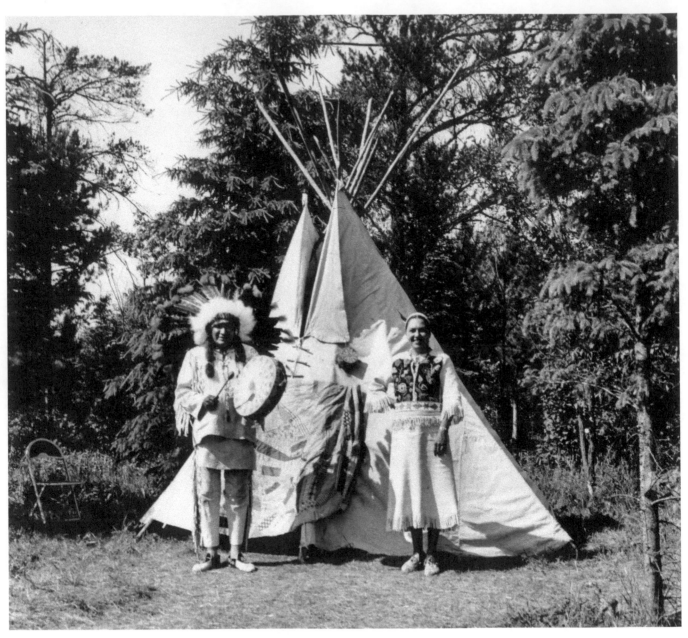

A Native American couple poses in front of a tepee at Itasca State Park during the Minnesota Territory Centennial pageant. The headwaters of the Mississippi River are inside Itasca State Park.

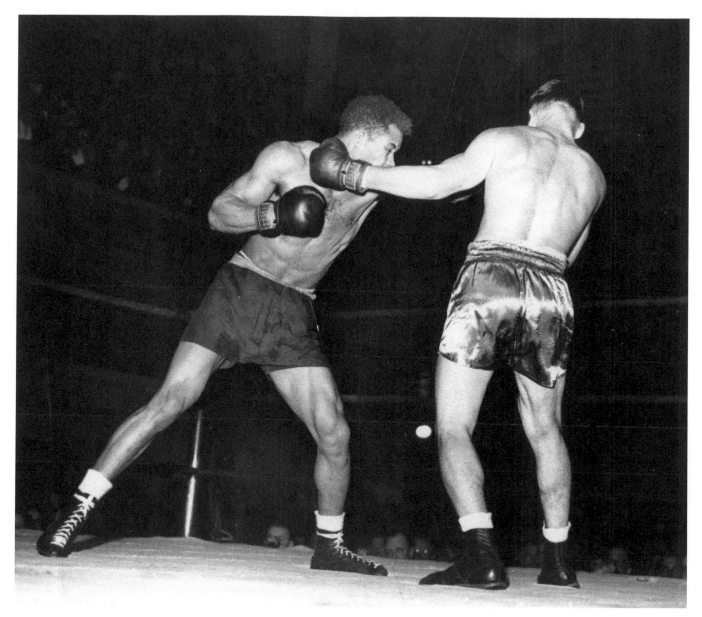

Pudgy Thurston, on the left, takes on an opponent in a 1950s boxing match. This event was an activity of the Hallie Q. Brown Settlement House, which served St. Paul's African American community. Organized in 1929 (though its origins date to 1908), the settlement house offered a host of classes, including art and athletics. Similarly, the Phyllis Wheatley House served the African American community in Minneapolis.

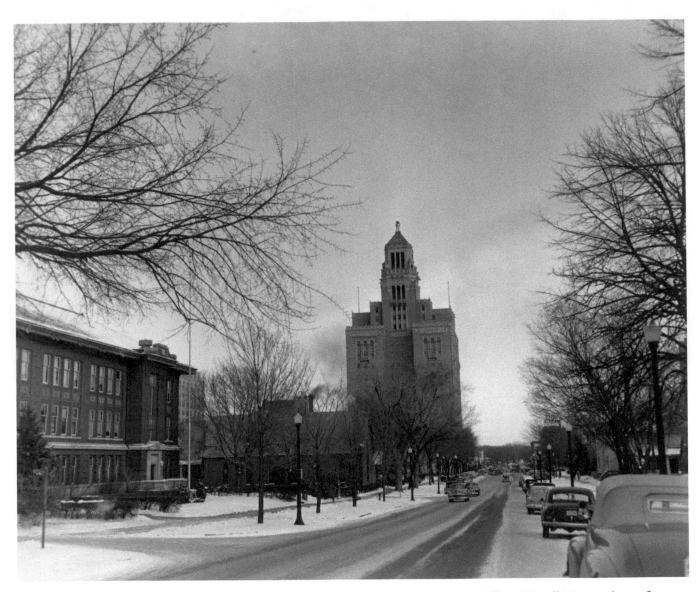

World-renowned Mayo Clinic (the tall building at center) in Rochester in January 1950. William Worrall Mayo, a doctor from England, settled in Rochester in 1863 and started a practice. His two sons joined in the 1880s. The Mayos invited other doctors to join their practice, a new concept at the time, leading to the establishment of Mayo Clinic in 1907.

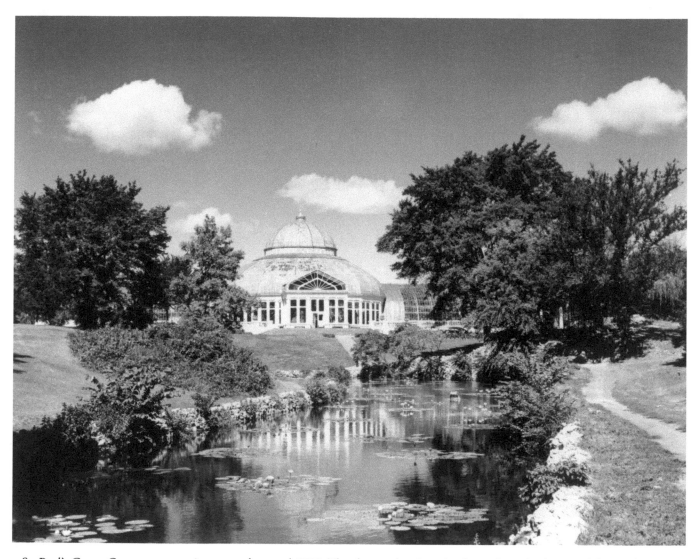

St. Paul's Como Conservatory, as it appeared around 1950. The glass-enclosed garden housed exotic plants and flower shows year round. The Conservatory is part of a picturesque area by Lake Como that was preserved by the city to develop into a "landscape park" for "physical and moral sanitation."

Notes on the Photographs

These notes, listed by page number, attempt to include all aspects known of the photographs. Each of the photographs is identified by the page number, a title or description, photographer and collection, archive, and call or box number when applicable. Although every attempt was made to collect all data, in some cases complete data may have been unavailable due to the age and condition of some of the photographs and records.

99 MINNEAPOLIS-MOLINE COMPANY
John Vachon
Library of Congress
3c22731-LC-USF34-060226-D

100 ROADSIDE VENDOR, BEMIDJI
John Vachon
Library of Congress
8a04443-LC-DIG-fsa-8a04443

101 NEW ULM BUSINESS DISTRICT
Minnesota Historical Society
MB9.9 NU2 r10

102 TOBOGGANING
Minnesota Historical Society
GV3.77 p11

103 YOUTH FOOTBALL HALFTIME SHOW
Minnesota Historical Society
GV3.13 p48

104 STEPHENS BUICK FAIR TENT
Minneapolis Journal
Minnesota Historical Society
FM6.55B r7

105 SOLDIER BUGLING
Minneapolis Star Journal Tribune
Minnesota Historical Society
MH5.9 F1.7 p130

106 MINNESOTA SCHOOL OF BUSINESS
Norton & Peel
Minnesota Historical Society
Norton & Peel
137849

107 VULCAN KREWE
Minnesota Historical Society
MR2.9 SP9.1 1942 p2

108 MEEKER COUNTY MUSICIANS
John Vachon
Library of Congress
8c21002-LC-DIG-fsa-8c21002

109 QUARTER LAUNCH, PORT CARGILL
Minnesota Historical Society
HE5.14 m3

110 WARTIME WORKERS
Norton & Peel
Minnesota Historical Society
Norton & Peel
143859

111 NAVY RECRUITING
Minneapolis Journal
Minnesota Historical Society
E448.21 r2

112 SOLDIER ON LEAVE
Minnesota Historical Society
E448.251 r2

113 MOTHER READING LETTER
Minnesota Historical Society
E448.19 p19

114 MAJOR RICHARD BONG BROUGHT HOME FOR BURIAL
Minnesota Historical Society
E448.27 p2

115 V-J DAY CELEBRATION
Minnesota Historical Society
E448.17 r15

116 AGRICULTURE BUILDING FIRE
Minneapolis Star Journal
Minnesota Historical Society
FM6.55H p72

117 PLAYING HORSESHOES
Minnesota Historical Society
GV3.52 p8

118 JITTERBUGGING
St. Paul Dispatch and Pioneer Press
Minnesota Historical Society
GV1.3 m3

120 MINNESOTA PLAYGROUND
Minnesota Department of Conservation
Minnesota Historical Society
GV8.2 p10

121 SISTER KENNY MOVIE PREMIERE
Philip C. Dittes
Minnesota Historical Society
MH5.9 MP3.10 p35

122 GOVERNOR'S OFFICE CHRISTMAS TREE
St. Paul Dispatch and Pioneer Press
Minnesota Historical Society
GT4.81 p83

123 LITTLE TRAIN RIDE
Minnesota Historical Society
FM6.52 p18

124 REPUBLICAN HEADQUARTERS
George Miles Ryan Studio
Minnesota Historical Society
J2 1948 p6

125 PURE OIL COMPANY TRANSPORTATION
Norton & Peel
Minnesota Historical Society
Norton & Peel
184626

126 WAYZATA FLOAT
Minnesota Historical Society
MH5.9 WY9 p1

127 COLONEL BITLER AND SUN VALLEY
Minnesota Historical Society
GV3.214 p7

128 COUPLE IN FRONT OF TEPEE AT ITASCA STATE PARK
Minnesota Historical Society
FM6.413 p4

129 BOXING MATCH
Minnesota Historical Society
GV3.42 p18

130 MAYO CLINIC
Minneapolis Star Journal Tribune
Minnesota Historical Society
MO5.9 RC2 p7

131 COMO CONSERVATORY
Riehle Studio
Minnesota Historical Society
MR2.9 SP4.1Cc p27

Printed in the USA
CPSIA information can be obtained
at www.ICGtesting.com
JSHW072022140824
68134JS00042B/3737